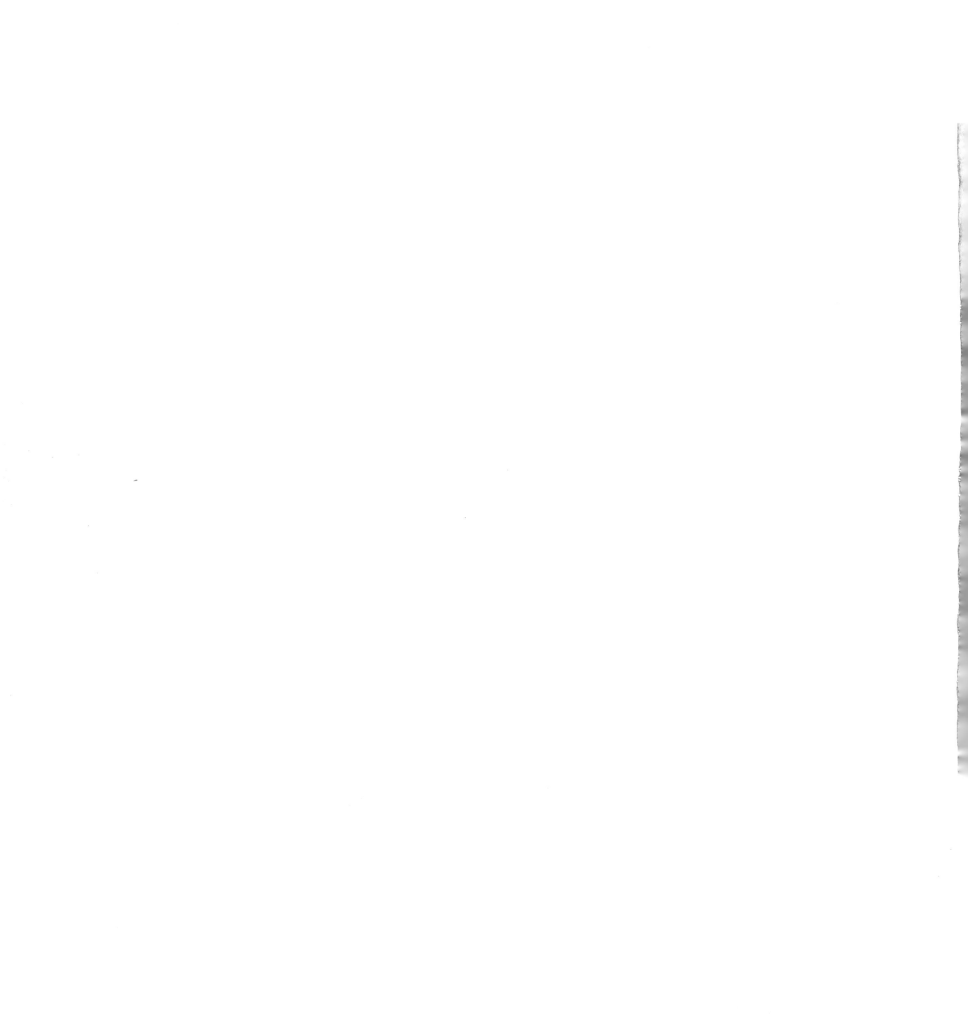

Spirit
of the
Huaorani

Spirit
of the
Huaorani

An Amazon people of Ecuador's Yasuni region

Pete Oxford & Reneé Bish

imagine!
Publishing

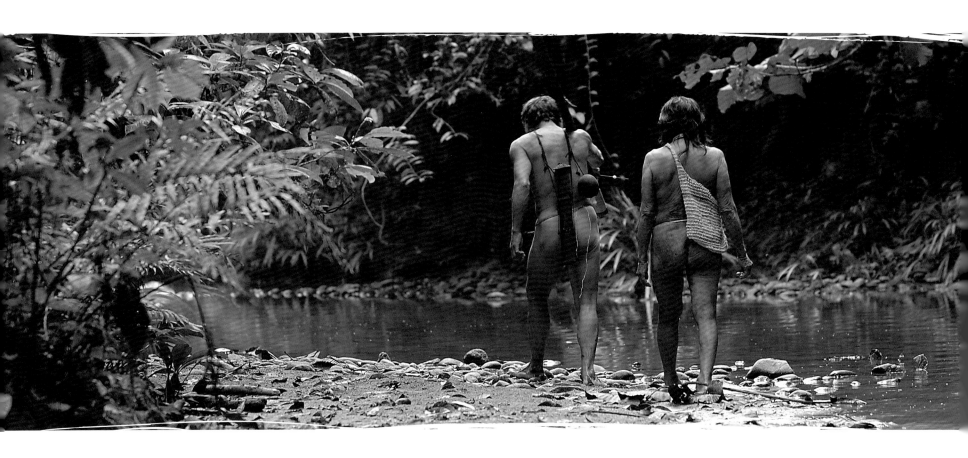

This book is dedicated to the Huaorani people as well as to their kin, the Tagaeri and Taromenane groups, who are both known to live in voluntary isolation from the western world deep in the Yasuní region of Ecuador's Amazon Rainforest.

Long may the spirit of wildness be with you...

...and Ben

"In the end, we will conserve that which we love. We will love that which we understand. And we will understand that which we are taught."

Baba Dioum.

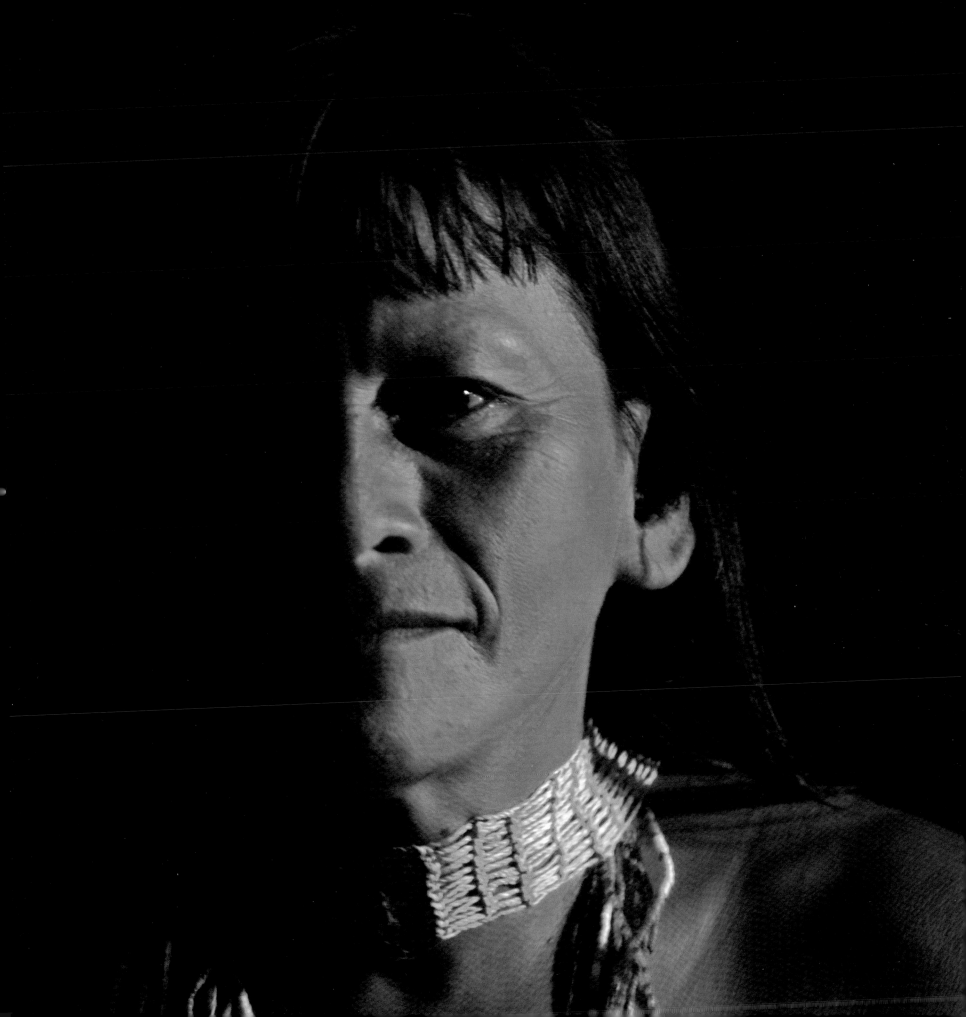

foreword

Like ourselves, Pete Oxford has been a passionate advocate for the Amazon for over twenty years. His admiration for, and appreciation of the Huaorani people of the Yasuní National Park reaches its apotheosis in this startling collection of photographs. Pete has captured the spirit of this clan in a hitherto unparalleled way. These tribal kin are the descendants of thousands and thousands of years of forest culture. Incrementally, their holistic way of life has been whittled away at, despoiled, by missionaries, by loggers, by oil workers, yet their resilience and their individuality shines through in every image. The Ecuadorian public, their closest neighbours, view them through the warped vision the west has imparted – the spearing of five Christians in the 1950's remains the abiding sensationalist headline whenever the Huaorani are mentioned – yet Pete seeks to reposition them in society, to reclaim the dignity which is so rightfully theirs.

We invite you to look deeply at these pictures, to witness the charisma and the humanity of a tribe under siege. Only two or three decades ago, they lived as they were intended to live. The world crashed in on them and threw them out of kilter. One half of the clan split off and now exists in voluntary isolation, deep in the jungle. These are the Tagaeri and the Taromenane. It is part of our insatiable, conquering curiosity to violate this exclusion zone and pry at them. Pete's photographs sidestep this urge, by giving us the Huaorani as they were intended to be. Whole. Happy. Proud. Free. Theirs is a culture that urgently needs our protection and esteem, as does the world they inhabit, possibly the most diverse eco-system on the planet. Their wealth of knowledge puts us all to shame. We must celebrate and salute our brothers and sisters of the Huaorani people. Looking into the pages of Pete's book is an excellent place to start....

Trudie Styler & Sting

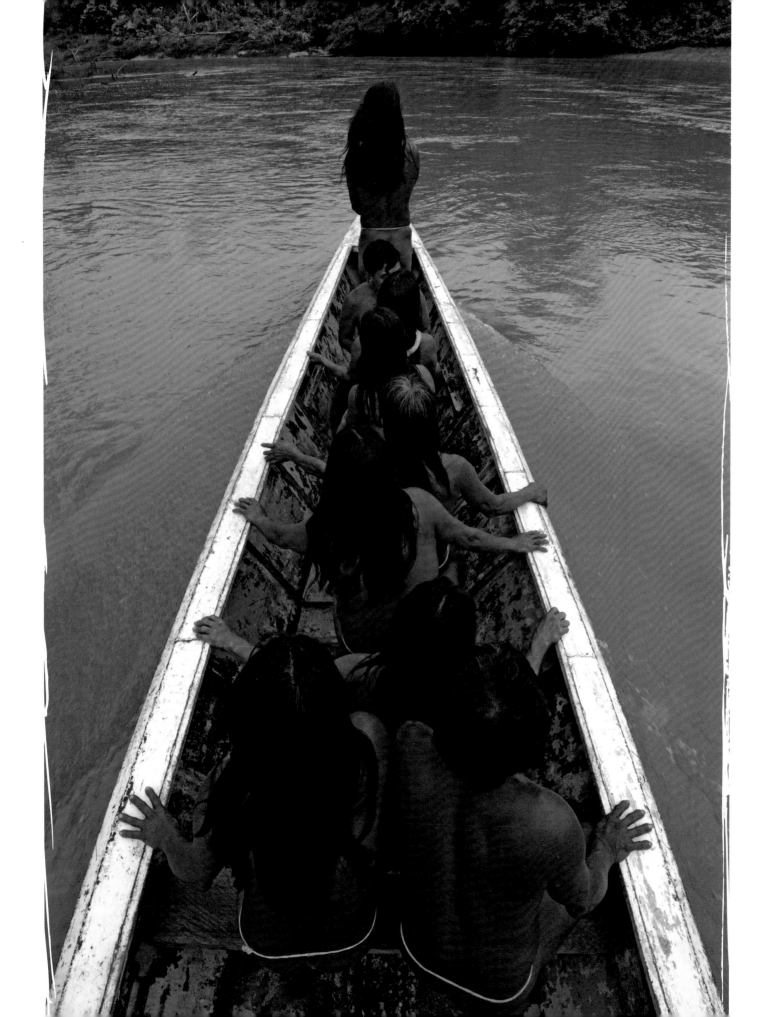

outline I came to live in Ecuador in 1985. **The Huaorani Indians (pronounced WOW-raan-ee, which translates** Through a mutual acquaintance, one of **as "The People") have lived for at least a thousand years deep** the first people I met in this diverse **in Ecuador's Amazon rainforest in complete harmony with their** country was a Huaorani Indian, Samuel **environment. Since their first contact with the outside world, they have** Padilla, son of Dayuma, a famous **unfortunately held an unenviable position within Ecuadorian society:** Huaorani woman who had fled from her **as Indians they are automatically relegated to the lowest social strata,** territory during inter tribal conflict as a **and within that strata they come in a resounding last.**

young girl in 1943 to become one of the first, in modern times, of her Stone Age tribe to reach the "outside." She had subsequently been befriended in 1955 by a missionary called Rachel Saint. Saint, immediately realizing the value of a "tame" Huaorani, set about meticulously learning the Huaorani language from her. Dayuma in turn was toured around the United States and paraded in front of thirty million television viewers as a savage from the jungle. Dayuma was converted to Christianity with great zeal, and eventually led back to her people to spearhead their religious conversion.

Some half a century ago, in 1956, five North American missionaries on a crusade to prepare the Huaorani for heaven were speared on an Amazon river bank. These men, knowing of the Huaorani's formidable reputation for defending their territory against outsiders, were nevertheless prepared to risk all in an effort to impose their personal beliefs on the "heathens" and save their souls from darkness. For one reason or another, the Huaorani killed the missionaries, destroyed their light aircraft and left the bodies in the river, a common practice for a tribe living within the laws of Nature and, from their point of view, a totally understandable reaction to the missionaries' presence. Today, to their detriment, the Huaorani remain notorious for that act. The public reaction at the time around the world was phenomenal. Headlines abounded along the lines of "Savages massacre missionaries deep in Ecuadorian jungle." Images of the dead in *Time* magazine further stirred civilized emotions. Indeed a great deal of fuss was made of the missionaries' deaths, one of whom happened to be Rachel's brother. Headline-makers were once again kept busy when she later returned with Dayuma to the same area and Christianized the "savages" involved in the killings – even forgiving them completely in a further heart-warming gesture. Public interest in the story ran high, and continues to this day with Hollywood producing a documentary about the killings as recently as 2005, followed by a feature film released in 2006. The Huaorani seem to evoke fearful echoes of our distant past, of our primordial inner fears of predators in the forest. An editor's dream indeed – particularly when the perpetrators of the spearings are sensationalized and totally misrepresented. These headlines and controversy remain the legacy that shapes the image of the Huaorani in the eyes of the vast majority of Ecuadorians and the public in general today.

So they were missionaries – was that important? Did that make them special? They were after all still trespassers whose purpose was to impose their foreign culture on the Huaorani – perhaps there in itself lies the true crime. Eventually however, the objective of the five dead "martyrs" was realized. Having watched original footage of the missionaries initial efforts to make contact, one certainly has to admire their pioneering spirit, their conviction and their tenacity. They worked hard for their goal. They used cunning methods such as circling overhead in a light aircraft while lowering a basket of presents and talking to the flabbergasted Huaorani on the ground in the Huaorani language (via a transmitter relaying to speakers hidden in the baskets). The unfortunate

Indians could not help but be impressed by this huge, benevolent, talking "wood bee." Their instinctive mistrust evaporated, and the naïve Huaorani were wrenched from their past, catapulted into the twentieth century to an uncertain future and changed forever.

Once accepted by the Huaorani, the missionaries' first act was to create an impractical sense of shame about the tribe's nakedness as well as converting them from their semi-nomadic hunting lifestyle by persuading them to grow crops. They encouraged the Indians to cluster in more permanent groups where the Bible could be more effectively read to them and they could be better supervised. However, Polio, previously unknown to the Huaorani, soon broke out, due in part to their unusually-high population densities. Many Huaorani lost their lives. Even though far more than five Huaorani died, there were of course no reciprocal headlines screaming "Missionaries massacre savages deep in Ecuadorian jungle."

The abnormally-high numbers in the settlements also quickly caused the nearby forests to be depleted of protein through over hunting. Thus, this naturally self-reliant people soon became dependent on the Christians, on foreigners from another continent. The egalitarian social doctrines of the Huaorani soon floundered and, as resources became more and more scarce, the previously unknown Western concepts of greed, possession and social stratification were introduced, thereby finally and convincingly "civilizing" them.

On whose authority I ask were Westerners allowed to impose their beliefs in the first place. The Christian God? I wonder what Buddha or Allah or the Gods of the Dulong people from northern China would think about this premise. Is the rule that any crusader who arrives first on the scene is allowed exclusive rights over heathen souls, free to peddle whatever foreign beliefs their conviction dictates? Shouldn't the Huaorani have simply been left alone?

This work has been an attempt to turn the clock back on the Huaorani tribe, to capture the essence of how they once were and how it is presumed both the Tagaeri and Taromenane clans still live today. The Tagaeri and Taromenane groups live in the Yasuní region of the Ecuadorian Amazon in voluntary isolation. They split from contacted Huaorani, choosing their traditional ways over a life of religion and change. In response to outsiders moving into their area, they continue to retreat deeper into the forest towards the border with Peru – a tough but honourable decision considering the putative glittering benefits of the "civilized" world.

I have been using the word "civilized" somewhat sarcastically up until now. Having spent so much time in the presence of Huaorani, I have come to question my preconceptions of what civilized means. They are a rich and resilient culture. Their language, Huao Terero, is not related to any other. Women have an equal voice within the community. The Huaorani understand the value of a healthy forest. They live in an egalitarian society. Their leaders are transient, elevated to overcome crises. Decisions are made on the basis of what will best benefit the community as a whole. That sounds very civilized to me.

Over the last two decades, I have had frequent contact with various Huaorani communities and individuals. I have never failed to enjoy their company, although the happiness I have felt is tinged by the sadness of what I have witnessed become of their world. My wife Reneé and I once hiked for three strenuous days through the forest to reach a Huaorani community to photograph for our first book on the Ecuadorian Amazon in 1995. On our next visit some ten years later, we drove on a new road built by the oil industry that dropped us at their doorstep. The relentless pressure upon their tribal territories means they are unable to move on to new pristine areas, leaving fallow the vacated land in

their traditional way. This would previously have caused situations of potential starvation within communities. However, the Huaorani, with typical lucidity and adaptability, have come to consider the intractable and imposed presence of the oil companies in their areas as simply another forest resource. Many now "forage" at the oil camps within their tribal territories, thereby creating the unfortunate negative image of begging Indians. The Huaorani feel no debt to the oil companies. In their eyes the Huaorani remain, without a shadow of a doubt, the true owners of their territory.

Samuel, Dayuma's son whose Huaorani name is Caento, was no ordinary Huaorani. He had been sent to Bible school in Florida, spoke perfect English, Spanish and Huao and, when I met him, was a techno-junkie who owned a bar in Quito. He had married Jeanne, an American nurse. They had a son called Shane. The last photo I saw of him showed him as a US Air Force pilot graduate, dressed in full uniform! Despite his city lifestyle, Sam still regularly "went native" in his tribal community unable to resist the call of the forest. I meanwhile remained fascinated by the breadth and pace of change that Dayuma's family had undergone over a period of some 50 years and three generations. Obviously the culture was rapidly dying out – and we, the industrial world, were the catalyst of that extinction.

This is a book I have wanted to produce for many years with the idea that one day, when the question is asked "Who were the Huaorani?" the curious reader could turn its pages and glimpse behind the eyes of these true forest Indians, and realize they were much more than the sensationalized savages of lore.

From Huaorani I have spoken to who have had contact with them, the Tagaeri and Taromenane are feeling ever-increasing pressure from all sides. They have indicated they have the sense of having nowhere to turn. I wager that we will very soon see them relinquishing their hard-fought dream and stepping out of their isolation onto the world stage of bright lights and notoriety.

This book is published with the Tagaeri and Taromenane in mind, as much as it is an

This is not an anthropological book, such works are already in existence. This is about spirit and character. I am simply a photographer, a member of a different tribe, in search of a connection with my fellow Man. I hope it to be a sensitive vision of the Huaorani's human qualities, their charisma, their sense of humour, their incessant laughter and their simple *joie de vivre.* **And, I venture, if you were to find yourself amongst them in their own environment, an open mind would soon pierce the thin veneer of the T-shirts, boots and shorts they wear. The fabricated shroud of the developed world would melt away and their true spirit would come alive before you, just as it did for me in the images that colour these pages.**

homage to the contacted groups. My hope is that Ecuador's known, and possibly as yet unknown, non-contacted groups in their self-enforced exile from "our" world, can continue to live in the spirit of wildness. I urge that we can sate our curiosity and our apparently insatiable need to know who they are and how they live by referring to the approximation represented on these pages – so that we in the civilized world can respect their wishes to be left alone, recognise their territories and honour their right to self determination.

I understand that this book is not a vision of the reality facing the vast majority of the estimated 2,000 Huaorani as they live today. I accept that. In my images I chose to ignore the clothes, the plastic, the schools, the HF radios, the solar panels, shotguns and other trappings of Western society that surround them. In some cases I even cleaned up after them! I approached the project with the words of Henri Cartier-Bresson always in the back of my mind: "Taking photographs is to place the head, the eye and the heart in the same line of sight".

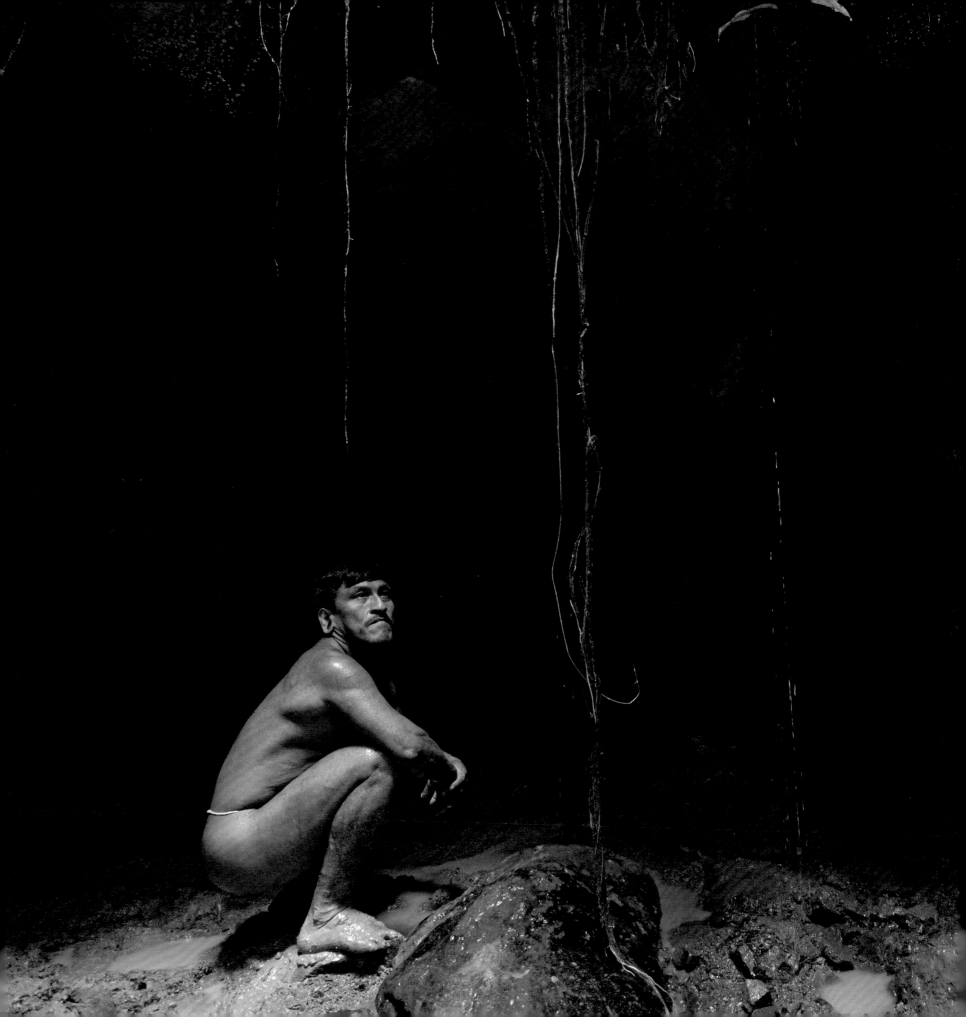

"The field has eyes, the wood has ears;
I will look, be silent, and listen."

Hieronymus Bosch (1450-1516), Dutch painter.

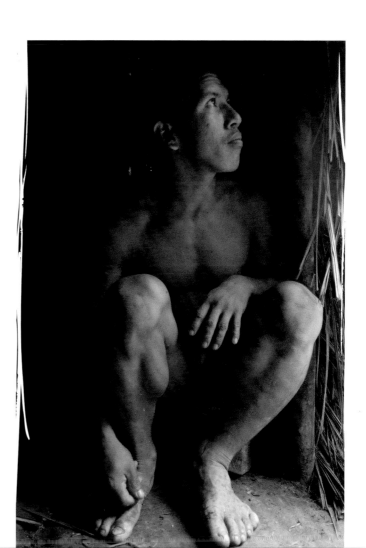

15

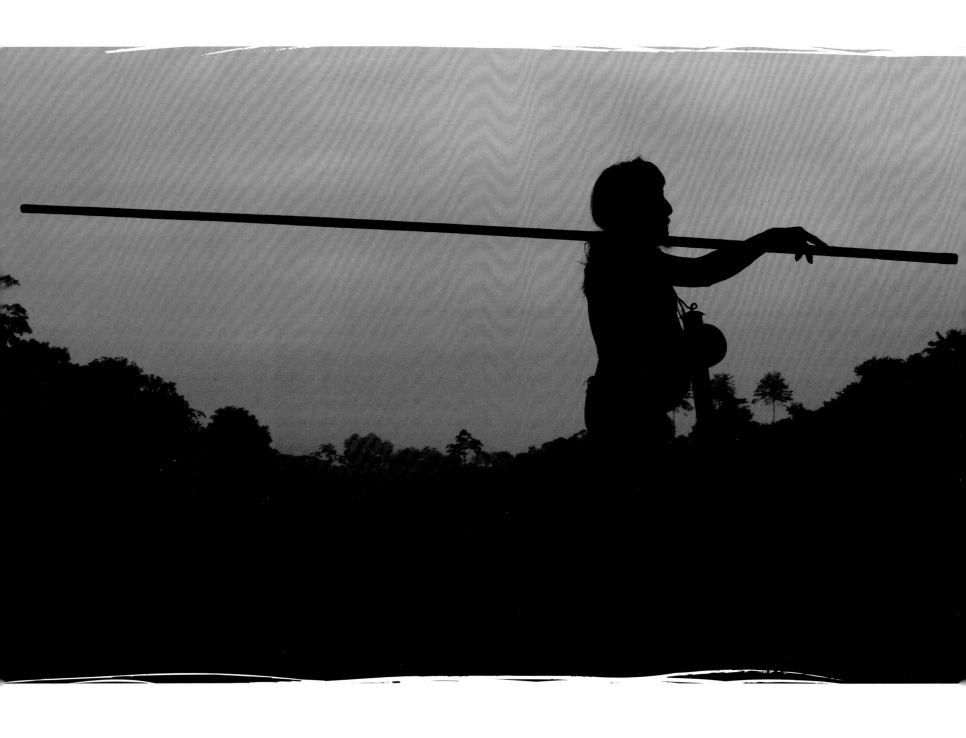

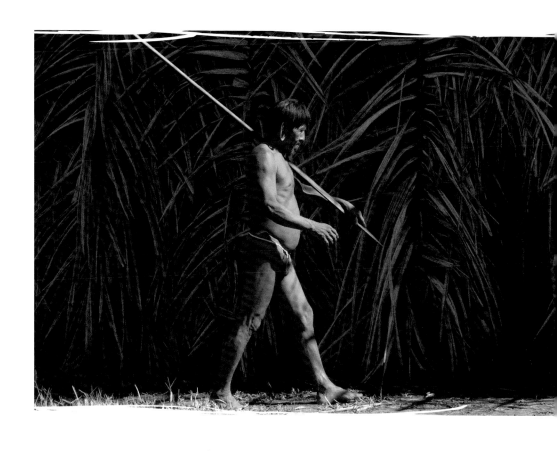

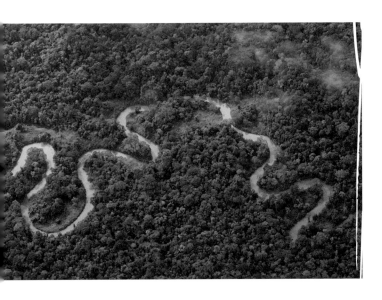

"The heavens themselves run continually round, the sun riseth and sets, stars and planets keep their constant motions, the air is still tossed by the winds, the waters ebb and flow [...] to teach us that we should ever be in motion."

Robert Burton (1577-1640).

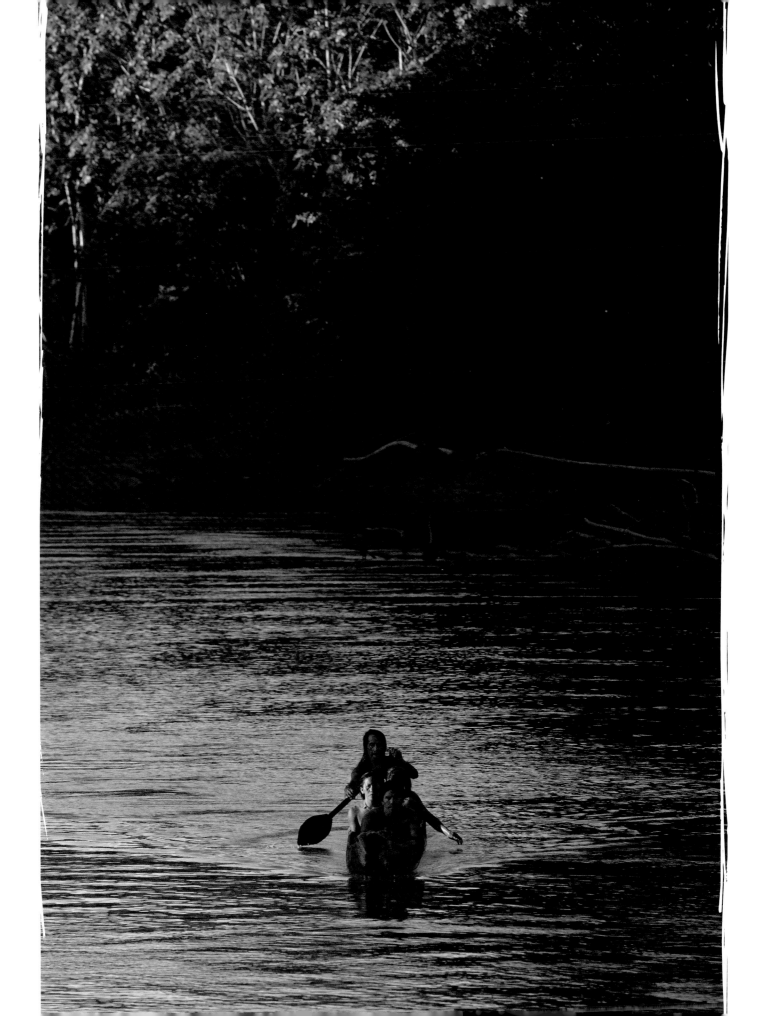

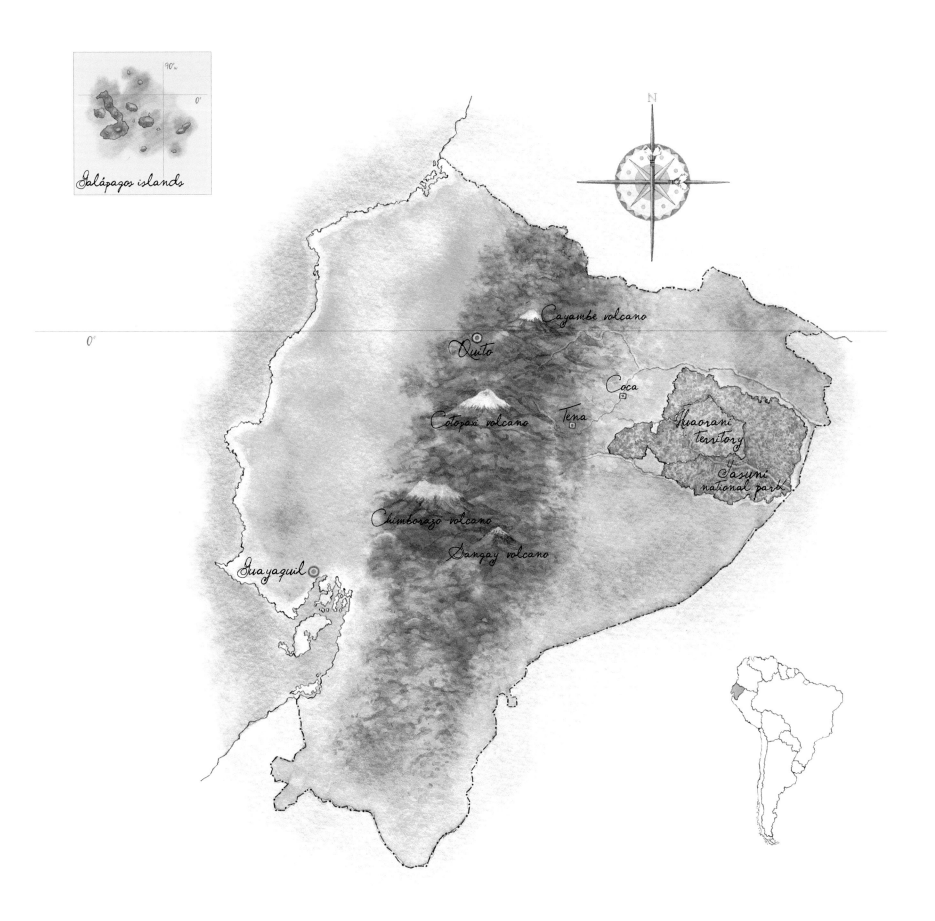

Galápagos islands

90°w

0°

0°

Cayambe volcano

Quito

Coca

Cotopaxi volcano

Tena

Huaorani
territory

Yasuní
national park

Chimborazo volcano

Sangay volcano

Guayaquil

N

the experience

Mist rose and crouched on the canopy like a puffy white snake sinuously mirroring the course of the lazy Amazon tributary below. We raced low over the treetops at 200 kilometres-per-hour (120mph) leaving vast tracts of pristine rainforest in our wake. Our helicopter gained altitude to help us find our goal: a clearing, half the size of a football field, somewhere 'down there'. The canopy was majestic, a carpet of myriad greens, it stretched as far as the horizon in every direction. Beneath the roar of the rotors, I couldn't help but wonder about the mysteries hidden in the half light below the dense layers of leafy tree crowns, and yet I was simultaneously struck by the idea that if we continued on our flight for just a short while longer, it would all be over. We would have flown out of the airspace of the planet's most biodiverse assemblage of life while crossing the entire ancestral home of one of South America's oldest and most traditional cultures.

Only three hours before I had left my home in Quito, nearly 3,000 metres (10,000 feet) above sea level in the heart of the Andes mountains. I had taken a cab through the chaotic traffic of morning rush hour, been whisked into the comfortable lounge of a private air charter company and was soon gazing down at the dry, brown, craggy mountain scenery below. A patchwork of small-holdings disappeared behind us as we raced downhill, eastwards towards the Amazon, on our 30-minute flight. The crumpled eastern cordillera began to smooth out while the browns turned to greens. As large plantations of regularly-spaced African palms began to dominate the view, I knew we were close to Coca, a bustling oil industry hub on the western edge of Ecuador's lowland Amazon basin.

Cocooned in the front seat of the helicopter, the comfort of my familiar world was stripped away. My concentration now focused on riverbanks and clearings, in case of engine failure, in case we needed to autorotate to relative safety. Even if we were

I had been a regular visitor to Coca since 1991 when I had worked as a professional tour guide in the rainforest. In those days the town had been truly repugnant to me. Crude oil was sprayed on the muddy tracks, which then passed for roads, prostitutes earned a good living from the oil crews and the whim of the local top officials was law. Today, although greatly improved, my vision was tainted by my past experiences. So I felt a sense of relief when the chopper took off and left Coca behind.

to survive an impact, could we survive for much longer, I wondered? I had spent a total of two-and-a-half years living in the Amazon. I was certainly no jungle novice, yet what skills did I really possess? How long would it take me to construct a rudimentary shelter, something I had watched Meñewa build with the greatest of ease in a few minutes on a previous visit? Could I really climb the forty-metre (130-feet) *chonta* palm to harvest its fruits? Were they even in season now? Fishing would seem like the easiest source of protein. But I would have to identify the fish-poisoning vine *barbasco* first. Maybe I could spear a fish through the murky waters. I could try... Even finding a river in which to fish wasn't at all obvious. With little or no reference to the sun beneath the canopy, especially hard on the equator, direction was more guesswork than science. Perhaps my questions were academic anyway.

Within half an hour, we were flying over an area inhabited by fearsome and as yet uncontacted tribes: the Tagaeri and Taromenane groups. The incongruity of the juxtaposition of my high-tech flight and their Stone-Age existence was both compelling and saddening. I couldn't help asking myself what they thought about the frequent drone of oil industry helicopters overhead, or what possible hope these last free spirits could have of halting the disintegration of their traditional culture when confronted by the march of the insatiable machine of the industrialized world? How could they ever avoid being drawn into it and eventually consumed by it?

I was flying in for my second visit to the Gabaro Huaorani community, who are kin to the Tagaeri and Taromenane. The Huaorani today provide an 'example', if you will, of the intermediary stage of the process of contact and acculturation. For untold generations, they had lived in the forest virtually unchanged. Only half a century ago, they themselves had come face to face with the machine. Today, they wear its clothes, eat oceanic fish from small tin cans and are read to from a two thousand year-old book. Change has come, thick and fast. Their once true course is swiftly and inexorably being altered.

* * * * *

We arrive at Gabaro. The coarse dust buffets the inclined bodies of the welcoming committee who have braved the downdraught of our fearsome helicopter at the edge of the small clearing. I recognize the familiar faces of old friends. Making friends among the Huaorani people is easy: you are either welcome or you are not. If accepted, you are truly taken in and treated as one of the family. The sense of generosity abounds. What meagre amounts of food, shelter or possessions a person might call their own are yours to share.

My metaphorical path to Gabaro had been cleared by a Huaorani called Ima Nenquimo. Although I had had plenty of previous Huaorani contact while living in Ecuador, this particular project became possible when, by good fortune and coincidence, I met Ima who had been brought up and educated in Quito. Coincidentally, while I was preparing for this book, he was looking for a photographer to illustrate a book of Huaorani mythology which he had just finished writing. In order to complete my work, I had wanted to spend more time in fewer places, staying at the most traditional communities I could find. I thought it would be better to spend longer with a smaller number of people, accepting the likely repetition of characters, while hoping that the group would become as relaxed as possible in front of the camera, until, to all intents and purposes, I melted into the background.

Once known as "Aucas", a derogatory term meaning savages, the Huaorani who greet me with beaming smiles are no more hostile than the memories of my grandmother. I embrace an old man, Gewa, who takes off his crown and sets it atop my much larger head. Meanwhile, children gather around, rubbing my fore-arms and pulling at the unfamiliar hairiness, likening me to a woolly monkey.

Ima and I hit it off immediately. Ten days after meeting, we found ourselves in the Huaorani community of Bameno within the Yasuni National Park. While photographing the images to illustrate Ima's mythological storyline that often had to be staged and required that the Huaorani be naked and as traditional as possible, I was gradually able to take more photographs of the Huaorani relaxed and going about their daily routines. My portfolio of images grew. I soon realised that my own Huaorani project could also become a reality.

I have always loved the Amazon rainforest. As a biologist, I consider it one of my favourite places on Earth. The eminent British naturalist Charles Darwin exclaimed that "Epithet after epithet was found too weak to convey to those who have not visited the intertropical regions, the sensation of delight which the mind experiences [...]. The land is one great wild, untied luxuriant hothouse, made by nature for himself." I remember my first visit to Nature's hothouse. My first impressions were not dissimilar to Darwin's. With time, I also came to realize how benign this "wild, untied" world really was. Hollywood had it all wrong, as usual. Poisonous snakes? Anacondas? Jaguars? They

were all pretty much impossible to find, despite hours and days of diligent searching. Wasps, ants and hairy caterpillars were the most troublesome creatures I encountered. One thing that struck me on long walks was the sensation of neither progressing towards, nor leaving behind, a particular place. Points of reference deep in the forest were non-existent, or, as I later came to understand, very subtle. There were no mountains to leave behind or ridges to approach. I felt like an ocean fish swimming in deep blue water.

Everything in the rainforest seemed accelerated. Coming from the temperate regions of my youth, it was as if the new life of Spring, the luxuriance of Summer, the rotting of Autumn and the senescence of Winter were all compressed into just one day. Four seasons affected the same tree at the same time. Organisms either seemed to be eating or being eaten, foraging or waiting, warning or hiding. The forest also eventually revealed an orderly system in what had initially seemed random. Layers could be discerned. Wild plants, familiar to me as house plants abounded in the dim, warm and humid understory in similar conditions to those we like to maintain our homes. Epiphytic cacti grew on the canopy top, a harsh environment beneath the rays of the equatorial sun where rain and nutrient capture-and-retention is the limiting factor in survival. The rainforest for me is always a surprising, complex, contradictory and disorientating habitat.

Staying with the Huaorani, I am amazed by how quickly my life's woes and worries fall away. By sheer osmosis, values rearrange inside me, my worldview changes, I begin to question many of the mores I hold dear. I did not have to hunt to feed myself,

I understood how much of a foreigner I was in this environment while walking with Tage. He had been wearing a cheap plastic watch. I was never sure why he needed to know the time, or indeed if he even knew how to tell it. I asked him to remove the watch for my photographs, so he kindly took it off and placed it under a leaf at the side of the trail. Returning the same way several featureless and monotonous hours later, he lent down and picked up the watch from under one of hundreds of thousands of leaves we had walked past. He just *knew* the place – unlike me, who was trying to recognize the leaf.

nor did I expect the Huaorani to feed me. I had arrived self-sufficient. But it was obvious that my friends' attitude to food and food acquisition was completely different to mine. One hardly noticed a man reaching up for his blowgun and untying the quiver of darts from the string suspended above the fire (the driest place in the hut) or slipping quietly through a slit in the palm fronds of the hut to disappear into the forest. It was just like one of us leaving the house to pop down to the local shops. Imagine our lifestyle "makeover" if instead of calling for a take-out we had to stealthily creep up on a troop of wily monkeys and shoot them silently with a three-metre (10-feet) blowgun from 40 metres (130 feet) with poison-tipped darts we had previously crafted. Or if grabbing a bite to eat meant sprinting at full pelt, losing all one's bearings, after an angry herd of some 200 dangerous wild pigs in order to get close enough to spear one to death, with a weapon hewn from a felled palm tree, not to mention the risk that the spear might miss and the herd turn on their aggressor. Or we might simply trip and break a bone on the uneven terrain. Or even – and most of us would do this convincingly within two minutes of leaving a trail – just get lost. Can you imagine buying a week's worth of groceries and having to carry them home for three or four hours on a jungle trail? A mature peccary, weighing 45kg or 100lbs, is heavier than a large German Shepherd. It's hard enough to lift one off the ground, let alone lug it home for your dinner. Despite the prowess and skill involved in hunting, there was little or no ceremony

associated with it. When a hunter returned to the community with his prey, a peccary usually caused a stir, but monkeys or birds were taken for granted, expected. I compared this with the images of hunters posing with their "trophies" in my culture. Did my Huaorani friends realize how macho they were?

During my stays in the communities, new experiences and sensations fill my days. Over breakfast, a captive harpy eagle occasionally cries plaintively, laughter echoes from all around. White smoke curls upward from singeing fur on a monkey being roasted on the fire, slowly filling the hut. I watch, captivated, as the lips of a severed coati head, placed on the same fire to cook, contract into a snarl and the prehensile nose curls up bit by bit. Later on, the guts are removed from a white-lipped peccary. The stench is overwhelming. I sit in silent wonder as a young child, oblivious to the stomach-churning odour, crawls over the animal and plays a game of looking for ticks to pull off. Other children are also at play. They vie with each other to find the poison dart tips broken off inside the bodies of hunted monkeys and birds. My "health and safety" values make me wince as a five year-old, razor-sharp knife in hand, leans over the fire to slice a piece of meat off the carcass when feeling peckish. Another sound makes me turn. The old man Megatowe leans contentedly out of his hammock to hammer the femur of a howler monkey against the floor. The banging is followed by a sharp suck, as he gets to the precious marrow inside.

Many of the Huaorani men have muscles that ripple as if they have just stepped off Venice Beach in California. I couldn't resist comparing the two. At first they would appear complete opposites. The Venice Beach men spend hours every day pumping iron in order to impress the girls with their muscles, despite never putting their hard-earned physiques to any real use. Shopping trolleys have wheels, after all. The Huaorani's muscles are testament to his proficiency as a provider: he has to be as fit as the wild herds in order to run with them, catch his prey, kill it and bring it home. Could a Huaorani understand how California girls could be impressed by the mere aesthetic of muscles, which don't actually produce anything at the end of the day? I think not, even though he would be pleased to think that his muscles could have an impact on California girls. I noticed that Huaorani women seemed impressed by a hunter's skill and his ability to bring meat to his family's table. So, I came to the conclusion that when a California girl swoons over a steroid boy's biceps and washboard stomach, she is actually, subconsciously, attracted to his potential as a hunter.

Hammocks play a fundamental role in Huaorani life. No matter what the activity, everything it seems can be done from its cradling embrace. It is primarily a bed, often shared by more than one family member. It is laboriously made from the dried and woven fibres of the *chambira* palm. It serves as the main seat of the hut. Because of its pendulum suspension, it can be swung to reach a large radius without ever having to get up – ideal for the sapping heat of the Tropics. It can serve as a platform from which to eat, construct a feather crown, fashion a clay bowl, weave a split-cane basket, play, make love, cook, feed the pets, prepare poison for the blow gun darts, even make the blow gun itself, sharpen knives or chant. It is lightweight and resilient. And when it's time move on, it can be disassembled in a flash.

Preparing food with Huaorani is always an education. First, the fire is moved to an appropriate spot, determined by the prey to be cooked. Everyone, from the smallest child upwards, knows exactly how the animal should be prepared, be it macaw, parrot, peccary, fish or monkey. There are no tribulations from the chef regarding the menu. The meal is food, fuel. The Huaorani favour some meats, such as peccary, tapir and monkey, above others, but everything is relished as if tasted

for the first time. There are no sauces, salads, desserts or presentation involved. The choice is simple: roasted or boiled.

Meal times are always animated. Everyone shares plates and eating utensils. Stories of the hunt are often recounted with much gusto. Sounds – the dart flying through the air, the squelch of mud or the multifarious animal noises – are sewn into sentences like words. The cadence of conversation might only be occasionally interrupted by the dull thuds of an old woman chopping more wood to keep the fire stoked. Evening meals continue well into the night, long past the time that bellies are full. Stories are told and retold, children stay awake with the adults until, lulled by the voices, they finally fall asleep in their parents' arms.

I eventually retire to my tent, pitched amongst the huts. I lie down, exhausted, drifting in and out of sleep, allowing myself to be enveloped slowly by the cacophony of forest sounds that emanate from every point of the compass. As I lie with my eyes closed, the grunts, chirps and croaking of frogs, the chirrups of crickets and a million-and-one noises multiply, flashing colours on the lids of my tired eyes in a synesthetic dance. A particular sound stands out. At first I think it might be an animal. But then it becomes more distinct in my mind. I realise it is the old men of each household, beginning their night-time calling on the spirit of the jaguar to enter their bodies. It sounds like the chanting of Buddhist monks: a low, repetitive and mesmerizing incantation. On and on it goes, the river of syllables flowing around the village, off into the night air. The men are communing with the spirits, asking them where the peccaries will be in the morning, how to cure an ailing relative, what messages they are to communicate. The Huaorani elders always chant late into the night, just as their fathers and grandfathers and forebears did before them. The rhythmic singing of words stretches back through their bloodline to the origins of Man.

I imagine in the huts of the Tagaeri and Taromenane, somewhere off in the forests of Yasuní, their elders will also be evoking the spirits to help them, to come to their aid, to tell them what to do as the outside world closes in around them. I wonder how soon their chant will become a lament.

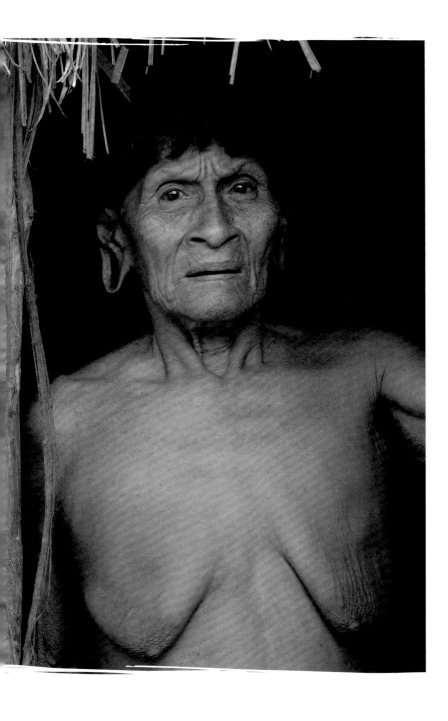

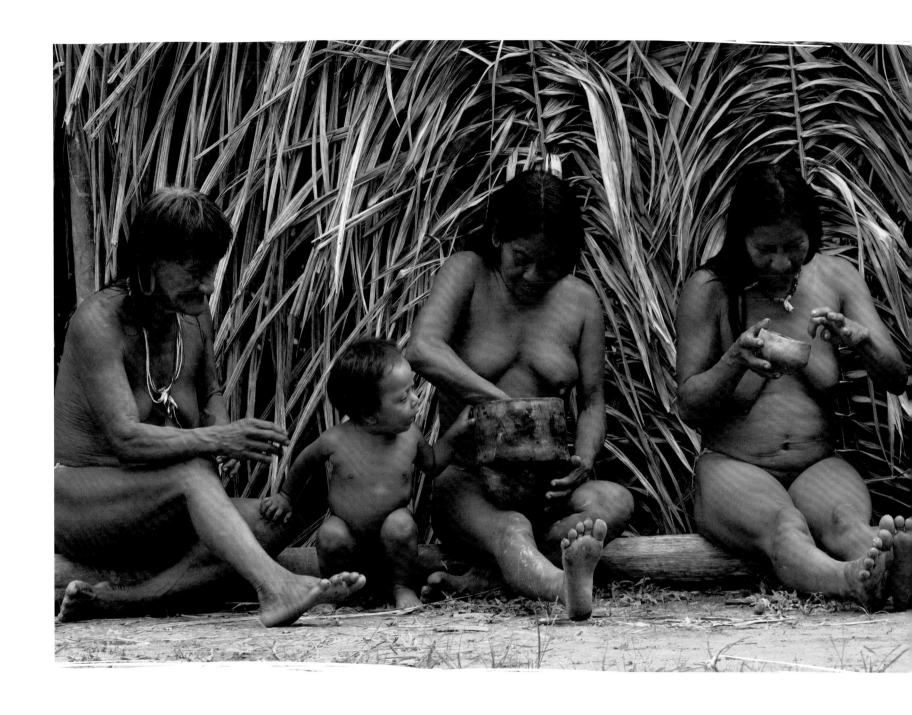

The women are drinking chicha. The drink is made by first boiling yucca and then chewing chunks of the boiled tuber. These are then spat back into the bowl, water added and the whole allowed to ferment.

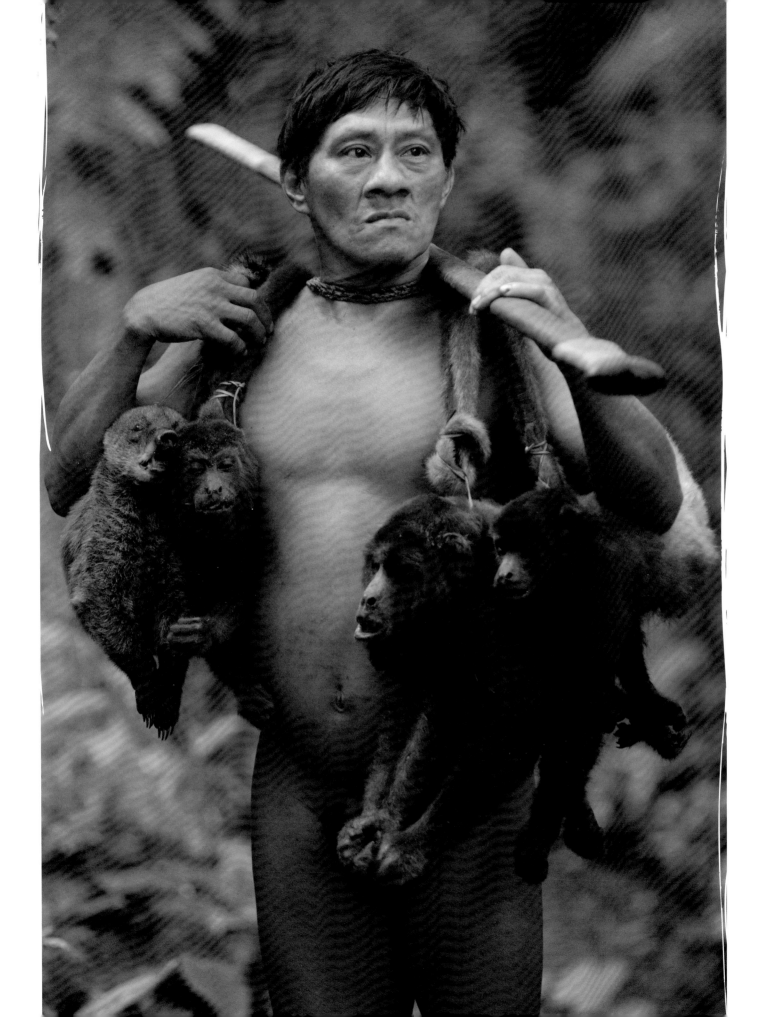

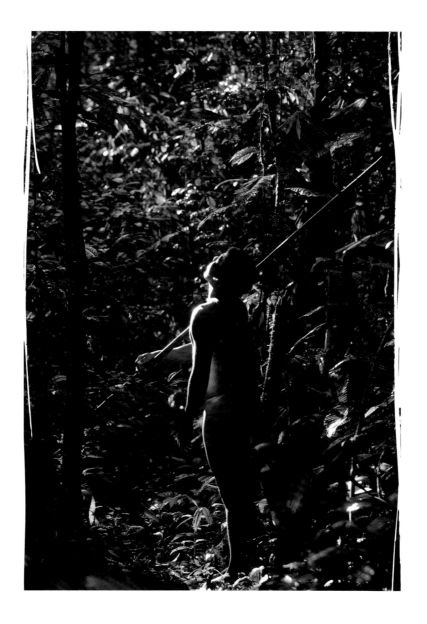

By using a silent blowgun, which has the range and accuracy of a noisy shotgun, a skilled hunter can often kill more than one of a group of animals before they realize what is happening. Ontogamo (left) poses with three red howler monkeys, *Alouatta seniculus*, and a South American coati, *Nasua nasua*.

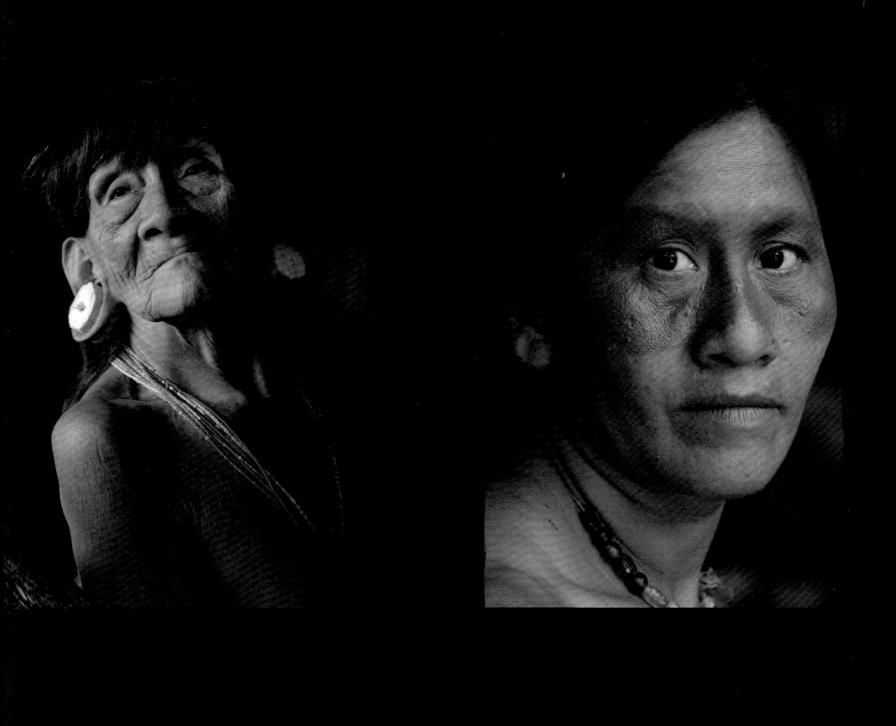

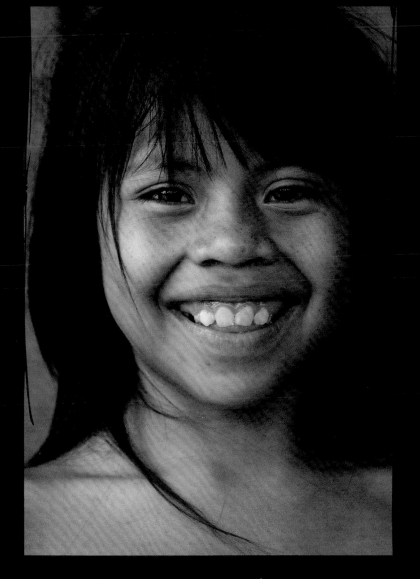
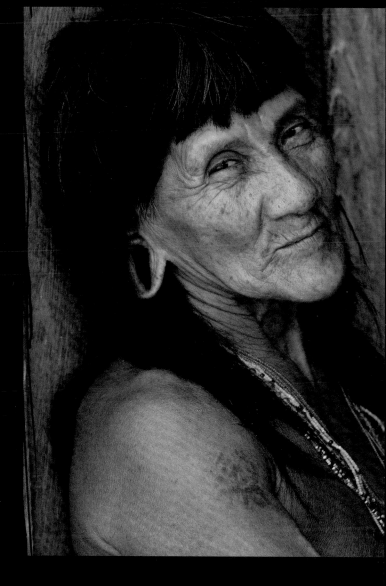

"I have always believed we are the same. We are all human beings."

His Holiness The Dalai Lama,
The Art of Happiness.

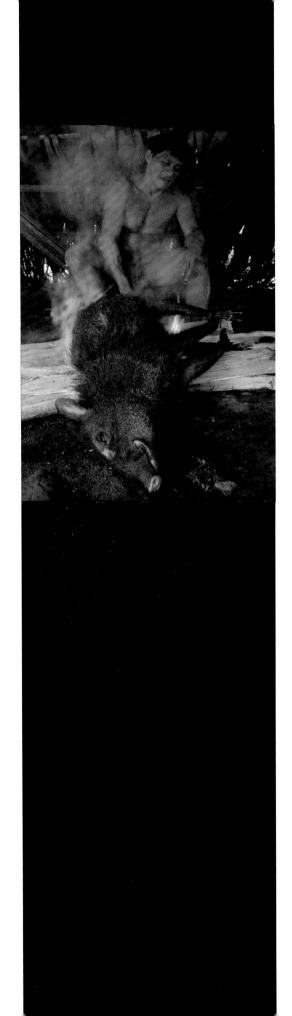

"Edible: Good to eat and wholesome to digest, as a worm to a toad, a toad to a snake, a snake to a pig, a pig to a man, and a man to a worm."

Ambrose Bierce, The Devil's Dictionary.

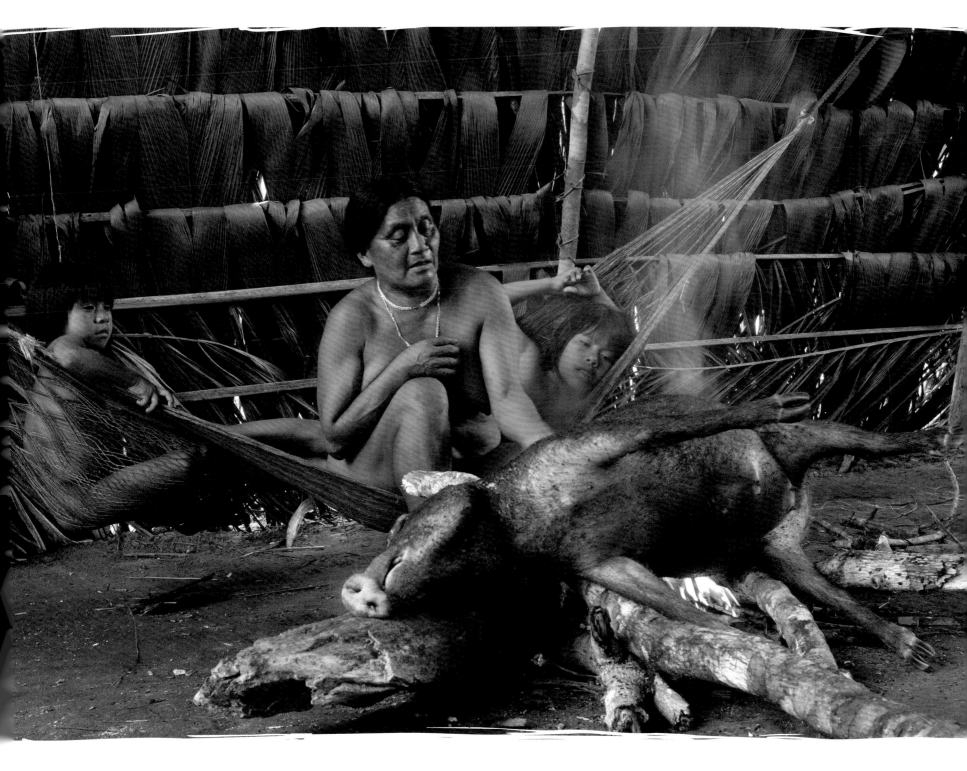

Peccaries are the favoured prey of the Huaorani as they represent a lot of meat. Before the carcass is butchered the hair is first removed by singeing the animal over an open fire.

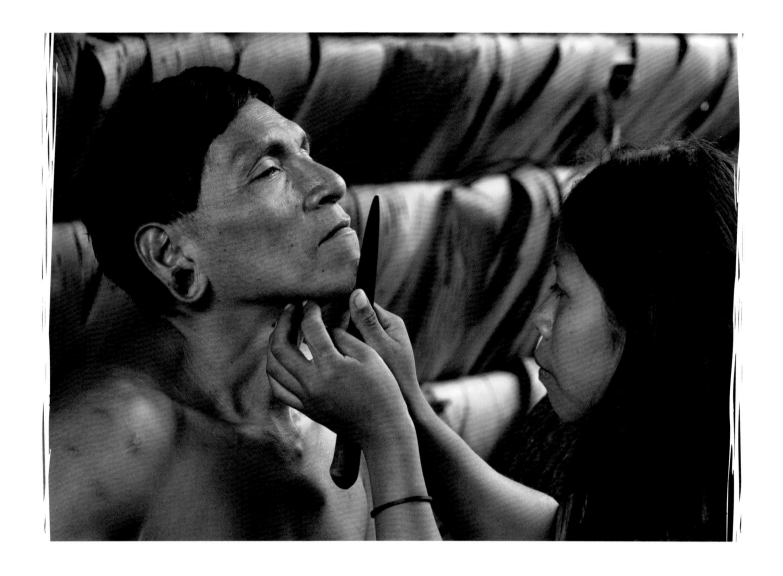

While Norma shaves her father to prepare him for a fiesta, which is a day's walk away, a girl from Bameno community combs her hair.

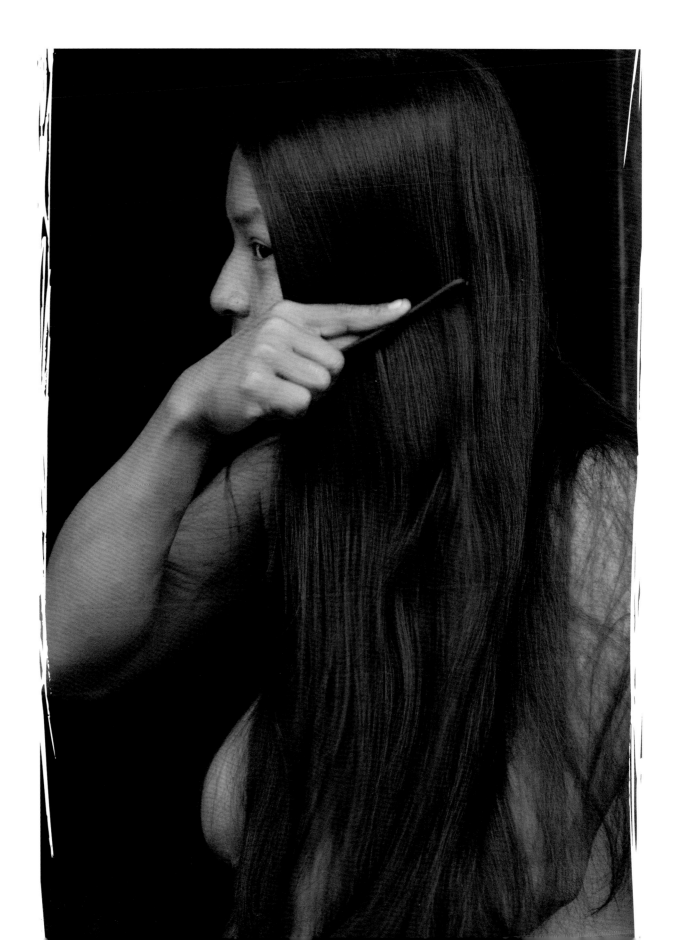

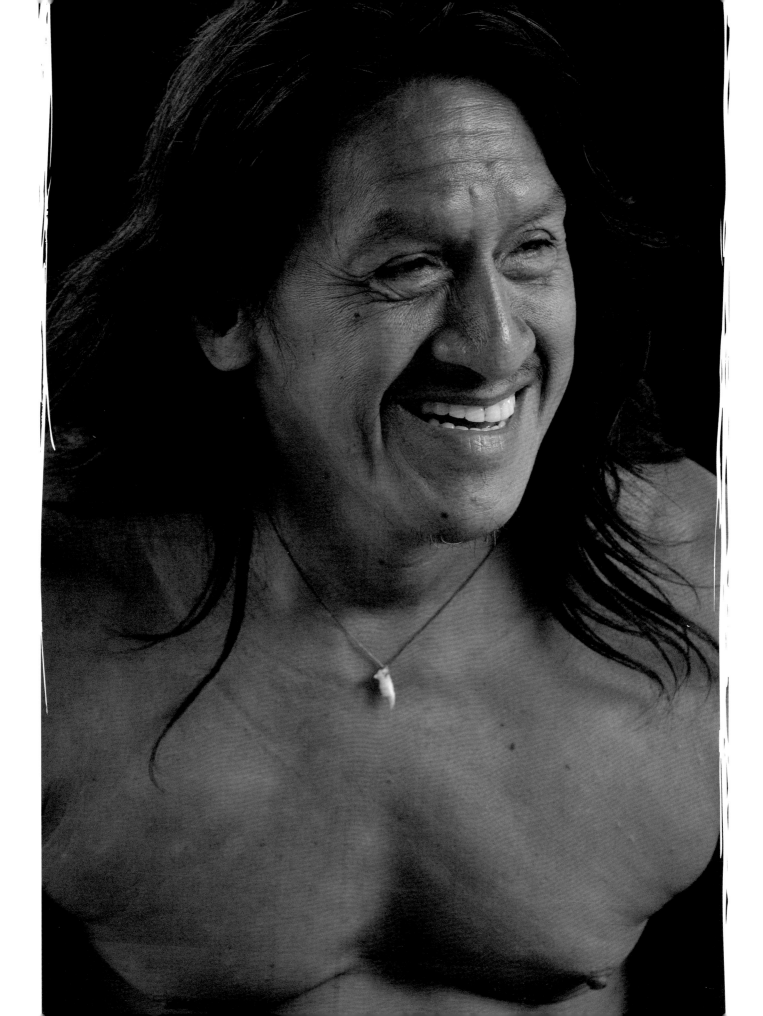

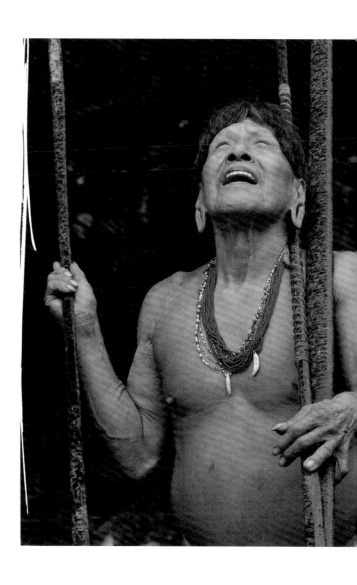

"To sit on rocks, to muse o'er flood and fell,
To slowly trace the forest's shady scene,
Where things that own not man's dominion dwell,
And mortal foot has ne'er or rarely been!
To climb the trackless mountain all unseen,
With the wild flock, that never need a fold,
Alone o'er steeps and foaming falls to lean,
This is not solitude, 'tis but to hold
Converse with Nature's charms, and view her
stores unrolled"

Lord George Gordon Byron (1788-1824).

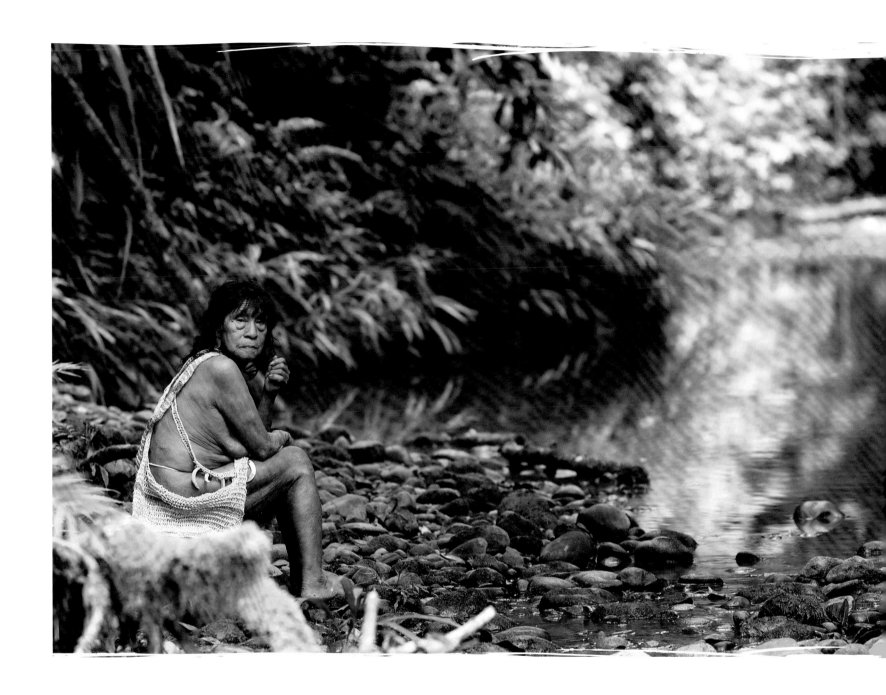

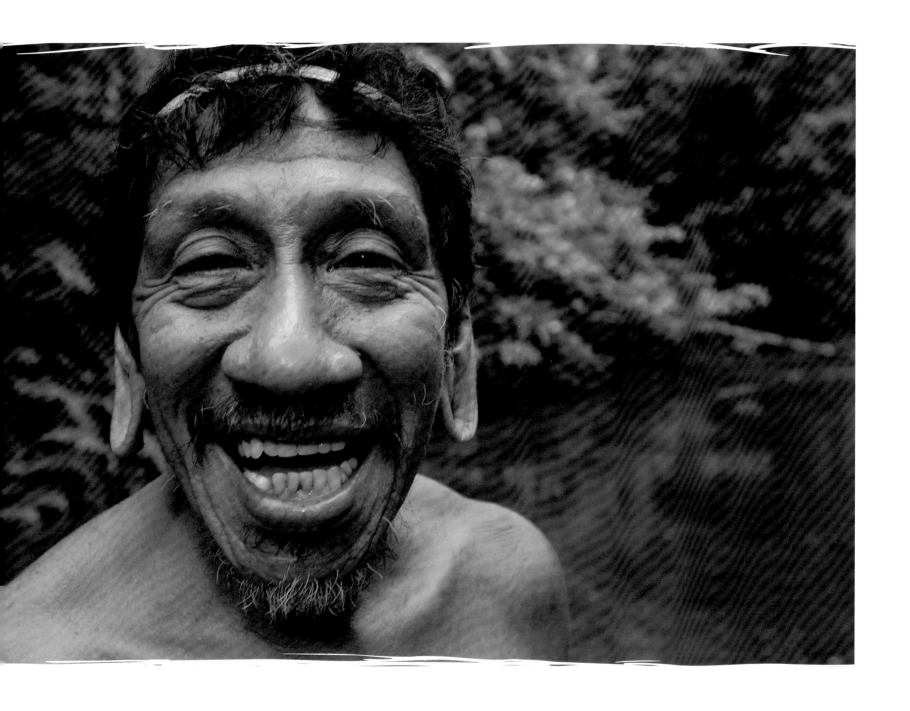

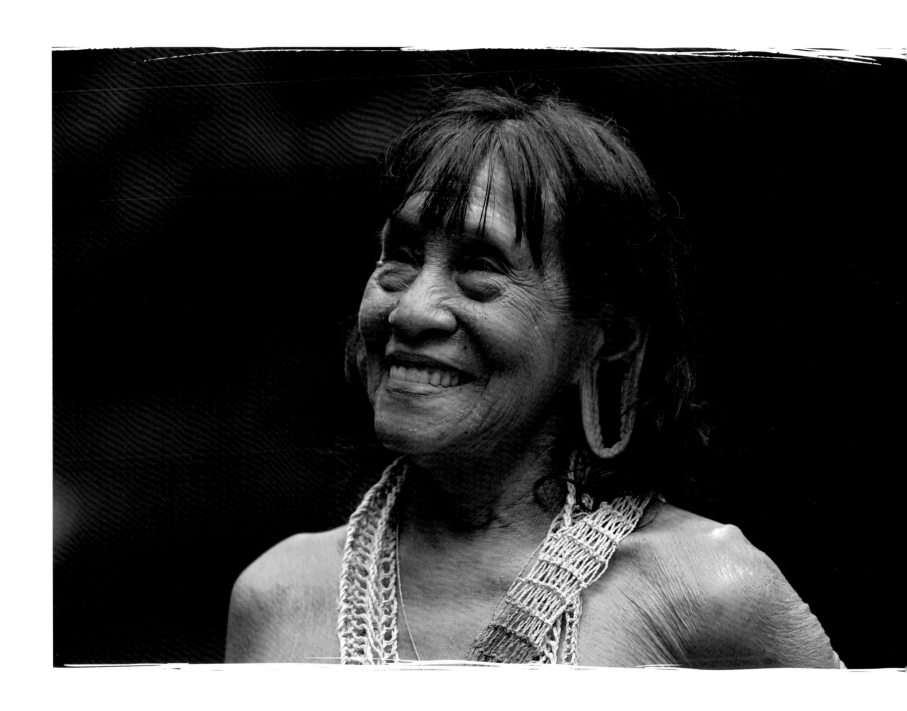

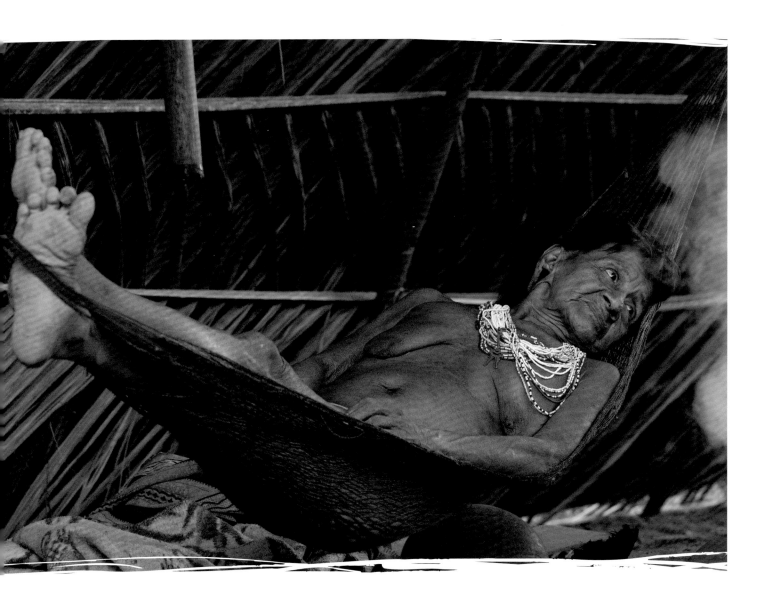

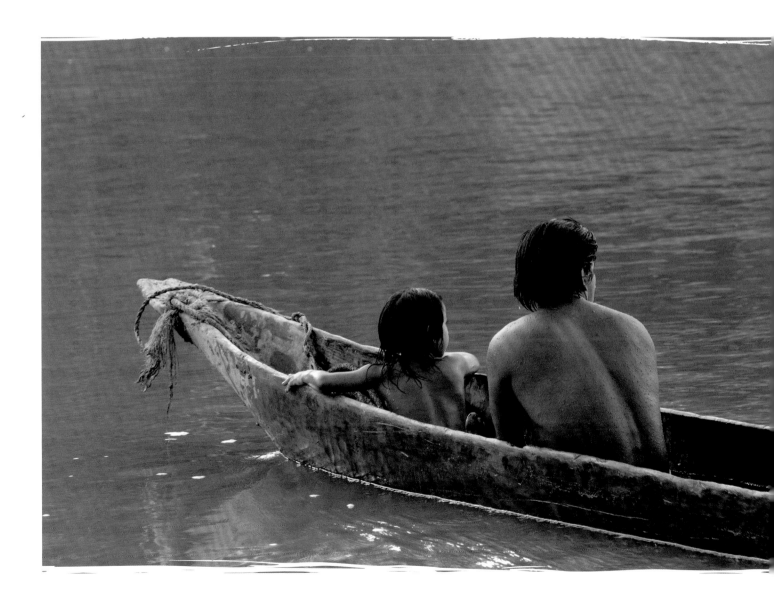

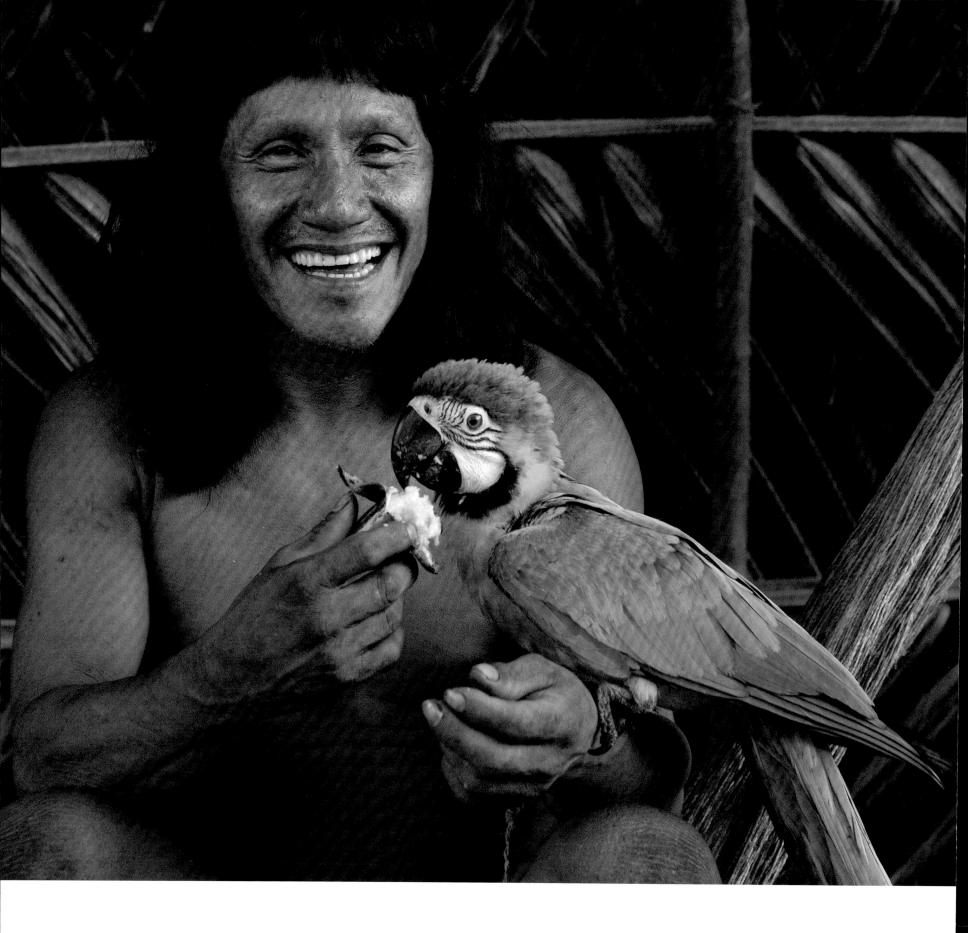

Wilderness is a resource which can shrink but not grow ...
The creation of new wilderness in the full sense of the word is impossible.

Aldo Leopold (1888-1948), American conservationist and writer.

The *chambira* palm, *Astrocaryum chambira*, is one of the most useful plants of the forest. The Huaorani make hammocks, string bags (shigras) and fishing nets from its fronds. First, they harvest young leaves, boil them and expertly draw out the fibres (below). They leave them in the sun to dry before rolling them into a twine on their thighs and weaving them.

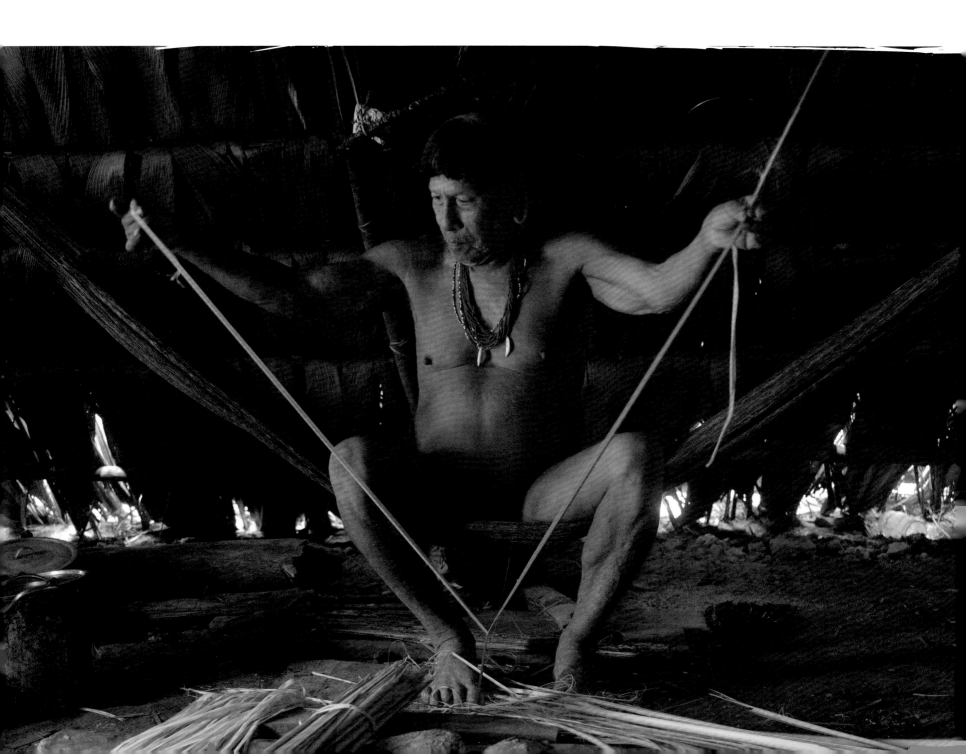

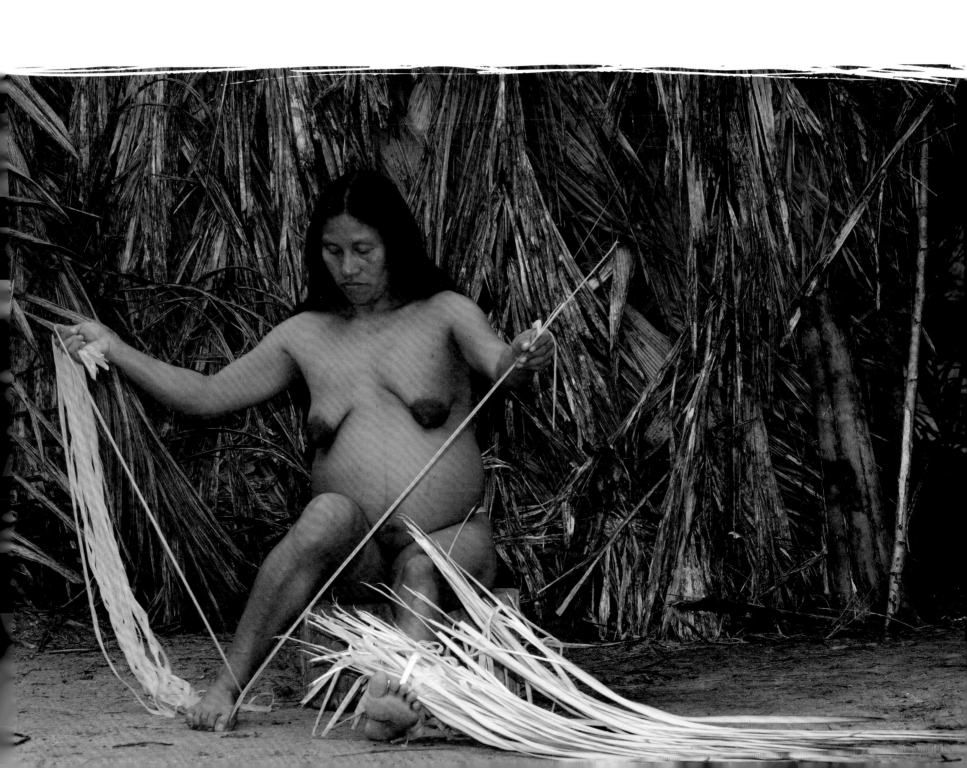

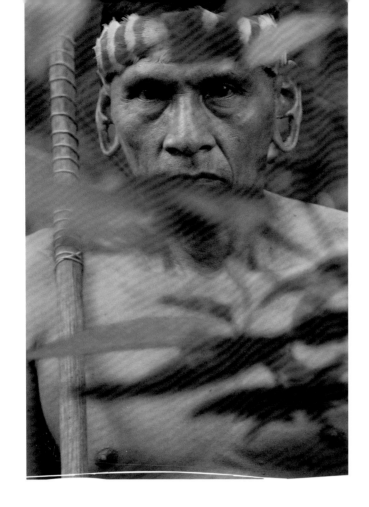

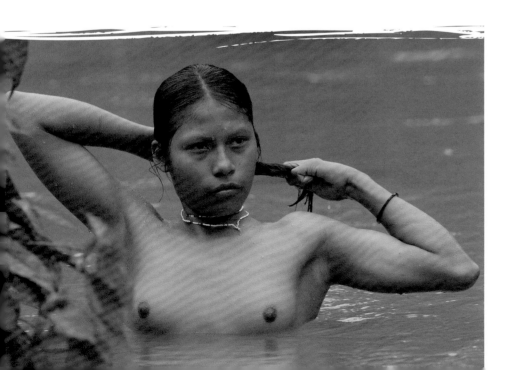

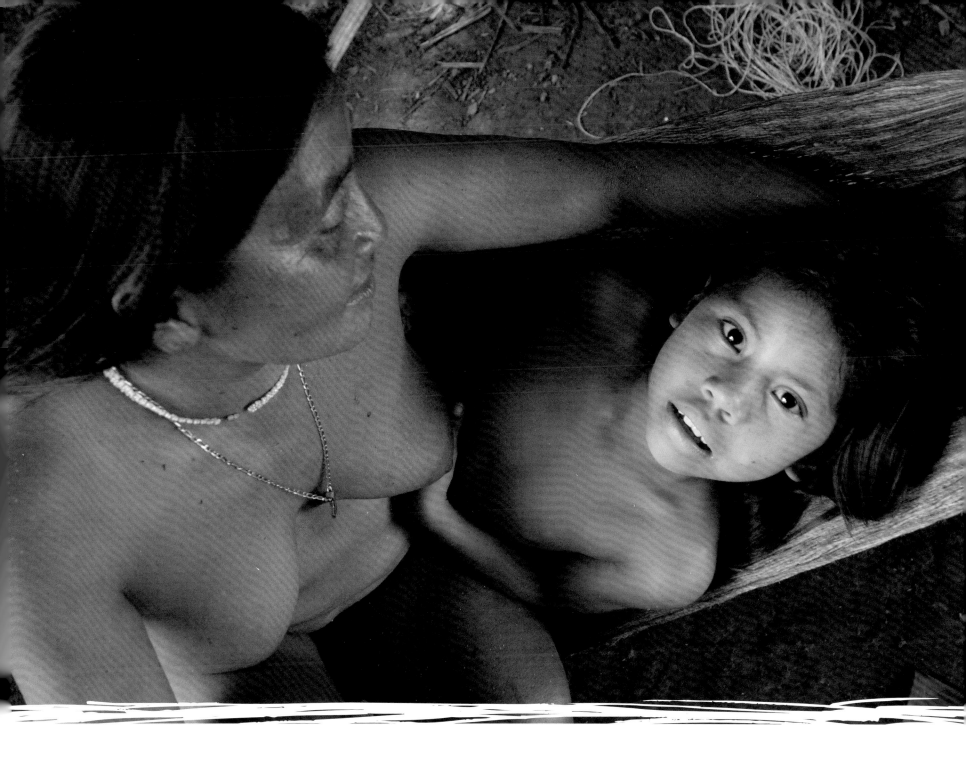

"Your clothes conceal much of your beauty ...

And though you seek in garments the freedom of privacy you may find in them a harness and a chain.

Would that you could meet the sun and the wind with more of your skin and less of your raiment,

For the breath of life is in the sunlight and the hand of life in the wind."

Kahlil Gibran, The Prophet,*1923*.

"Clothes make the man. Naked people have little or no influence on society."

Mark Twain.

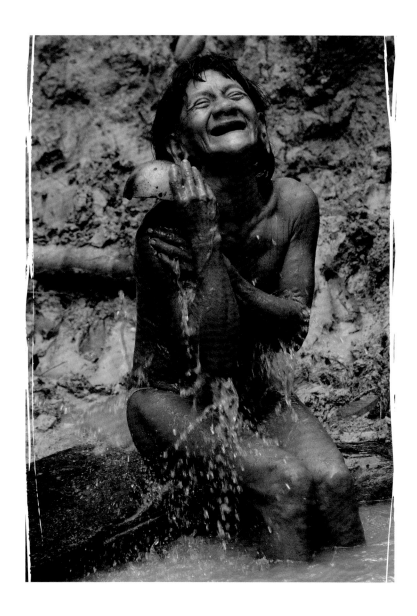

The previous page shows a man and woman wearing a *Komi*, a cord usually made of wild cotton. Because the *Komi* represents energy and power a Huaorani feels naked without it.

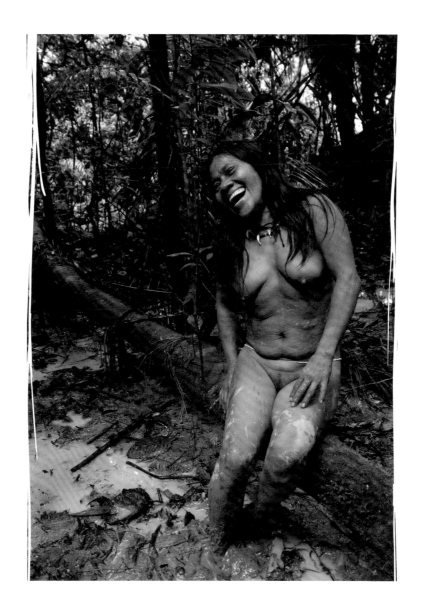

"Nothing is perfect but primitiveness."

John James Audubon (1785-1851), American ornithologist.

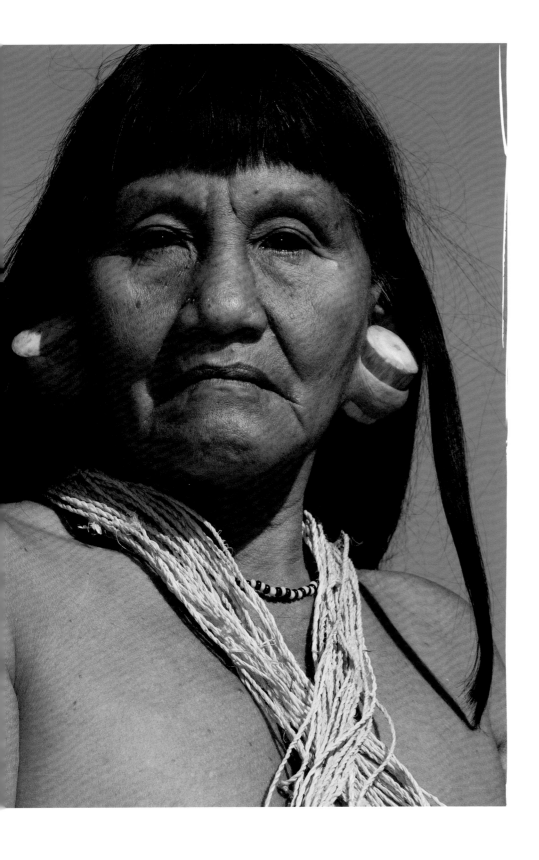

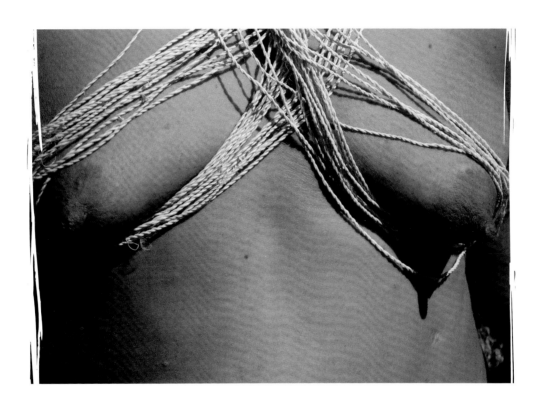

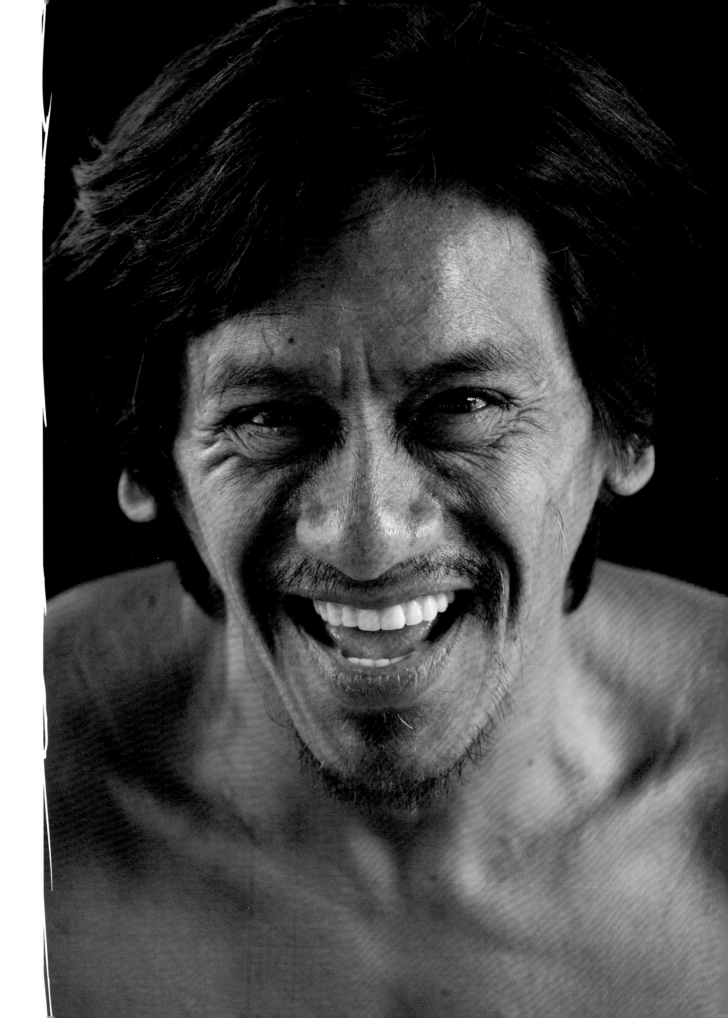

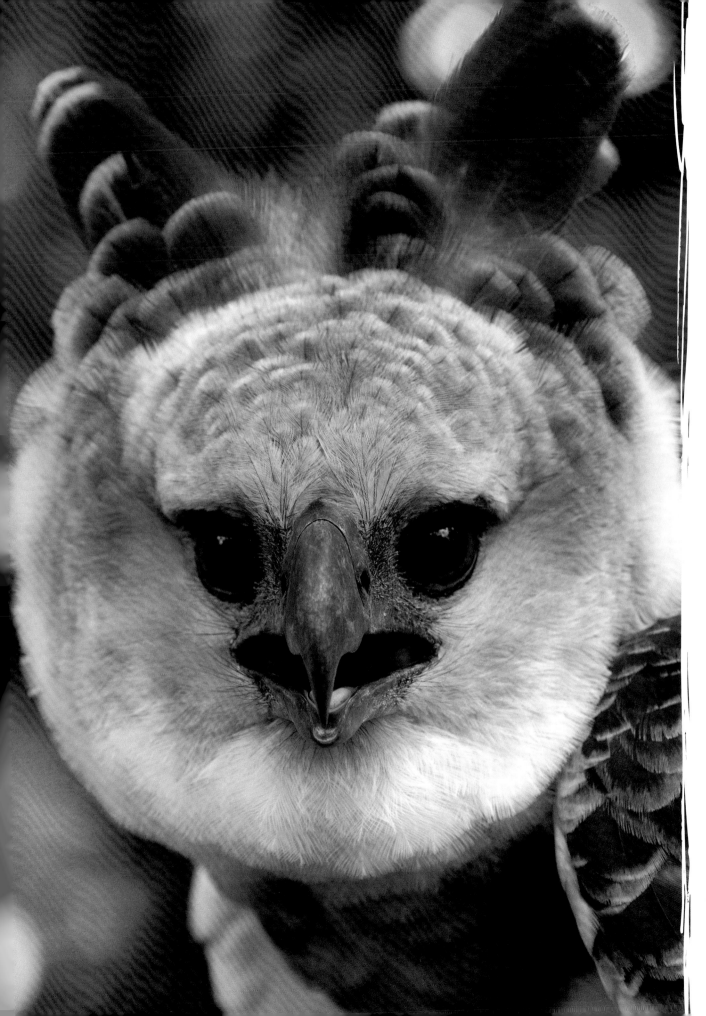

Portrait of a pet harpy eagle, *Harpia harpyja*, the world's most powerful eagle. A favoured pet amongst the Huaorani, it is revered as a deity. The tribe also use the harpy's feathers to adorn their headdresses and armbands.

Although small in stature, the Huaorani
are often very muscular and stockily-built.

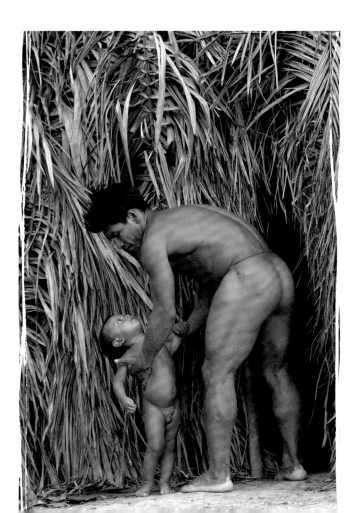

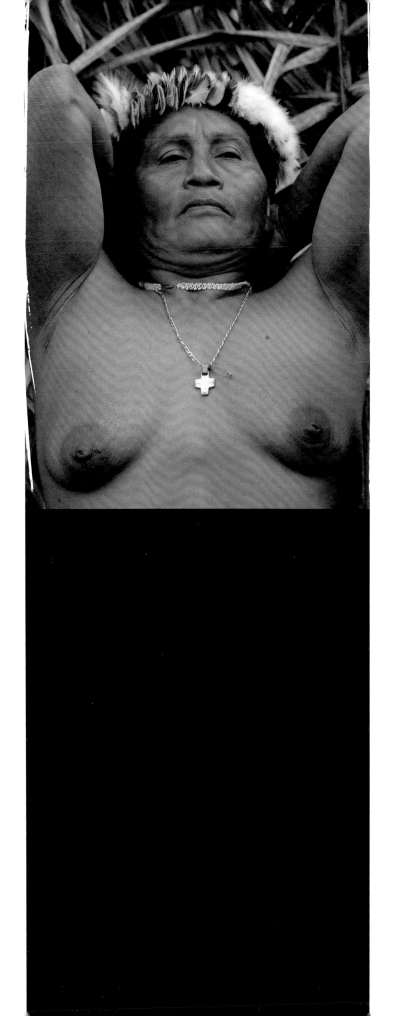

A woolly monkey, *Lagothrix lagotricha* shot and killed with a blowgun by Tage.

The total kills I recorded during nine days at the Gabaro Community:

2 White-throated toucans
2 Gray-winged trumpeters
2 Piping guans
1 White-lipped peccary
1 Collared peccary
1 Paca
3 Howler monkeys
2 Woolly monkeys
1 Squirrel monkey *
1 Saki monkey *
1 Coati *
1 Tamandua *
1 Mealy parrot
1 Dove
* hunted to feed their pet harpy eagle.

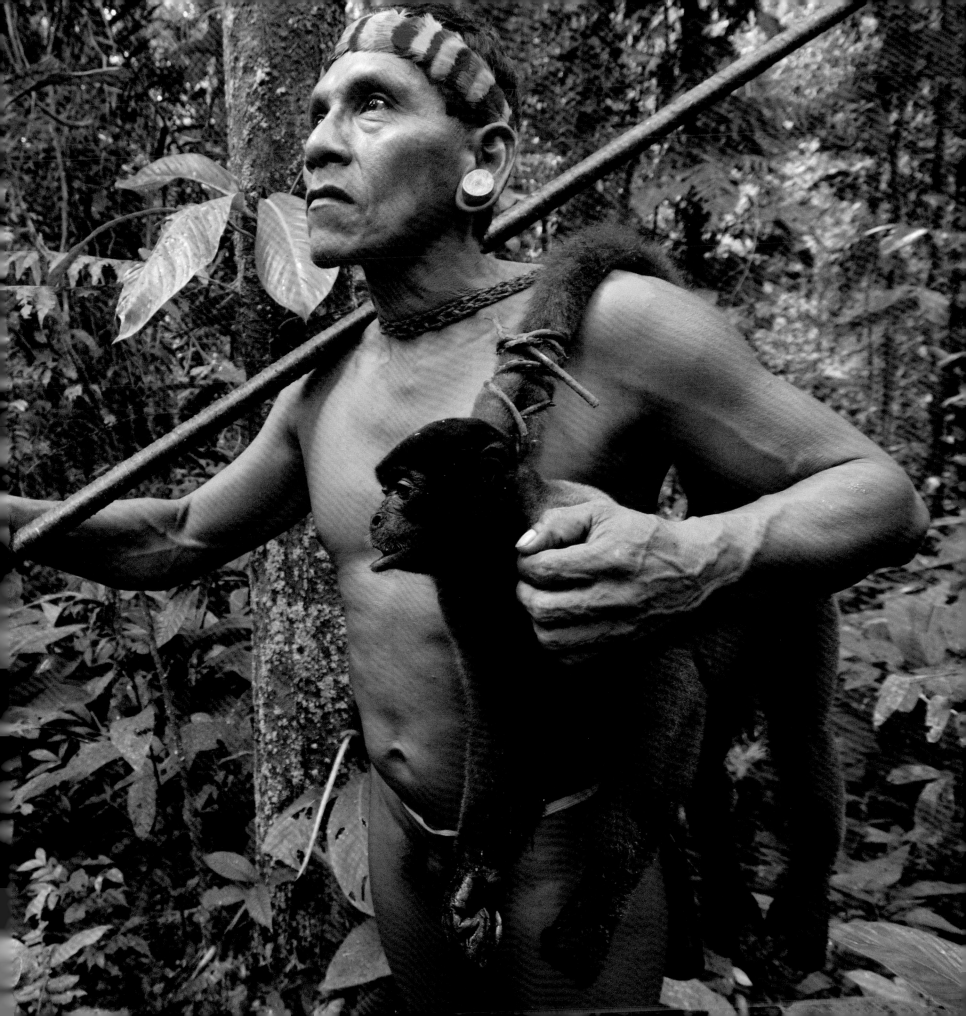

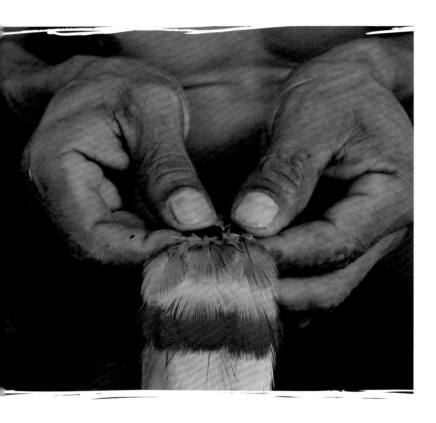
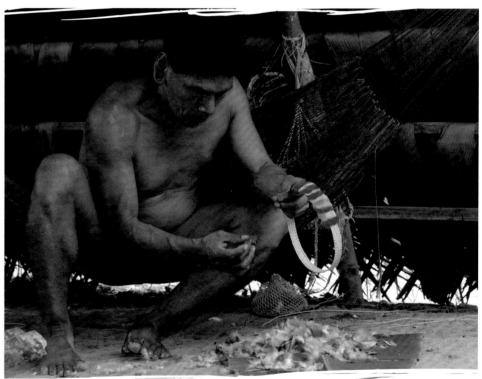

Macaws are common pets amongst the Huaorani. Not only do they provide entertainment and make good company, they also raise the alarm at a stranger's approach. Their feathers are occasionally plucked to use for decorative purposes, such as in the headdress that Tage is making.

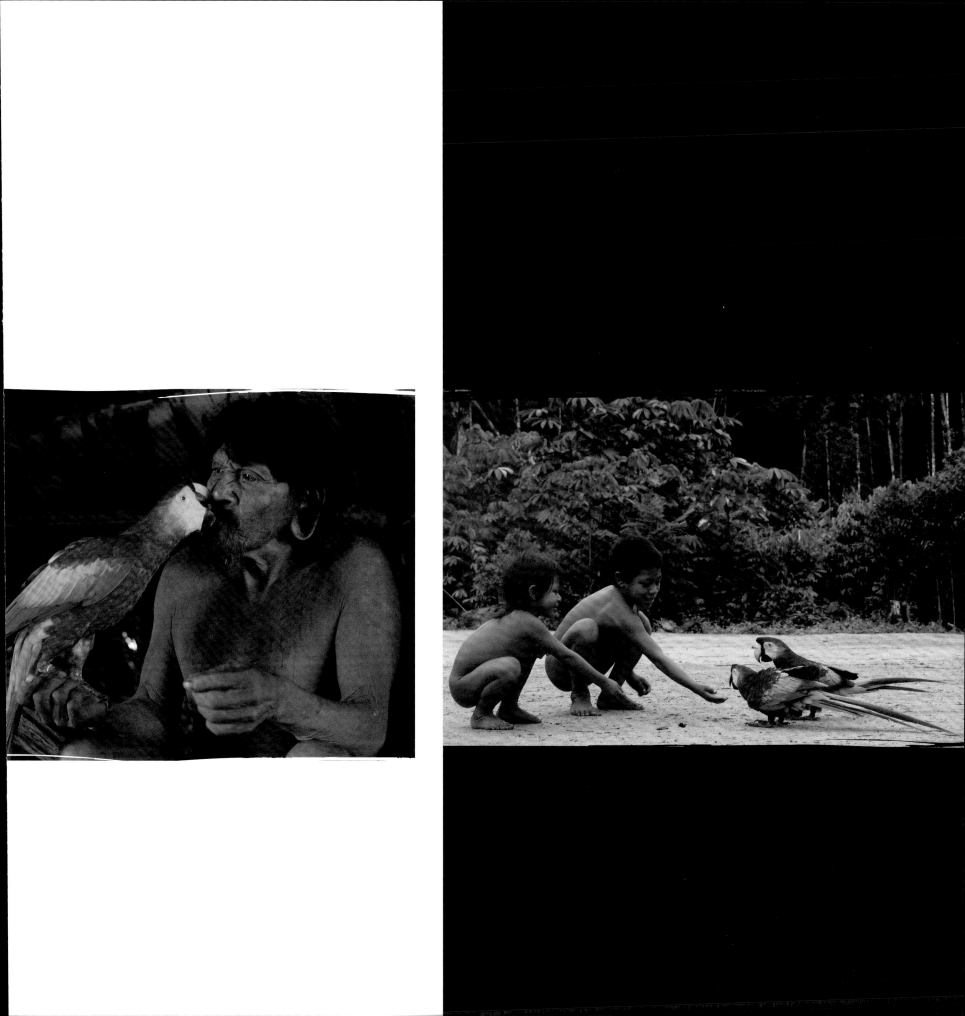

Rather than leave behind the pet black-headed parrot, *Pionites melanocephala* (left), the owners carried it on a stick from Ginta community to Gabaro. Having heard that I was photographing in the area, the Huaorani were curious. They arrived unannounced, in typical Huaorani fashion, and stayed for several days. The pet was provided with its own hammock (a discarded T-shirt) and soon made friends with the resident parrot.

Hanging down a hunter's back, the tubular quiver holds poison-tipped darts. The gourd is filled with the fluffy cotton of the kapok tree. The cotton is used to make the flights for blowgun darts.

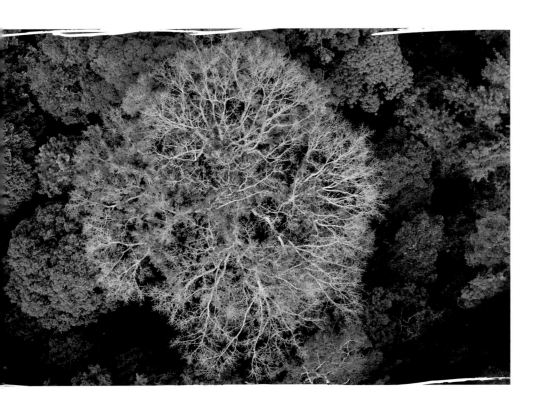

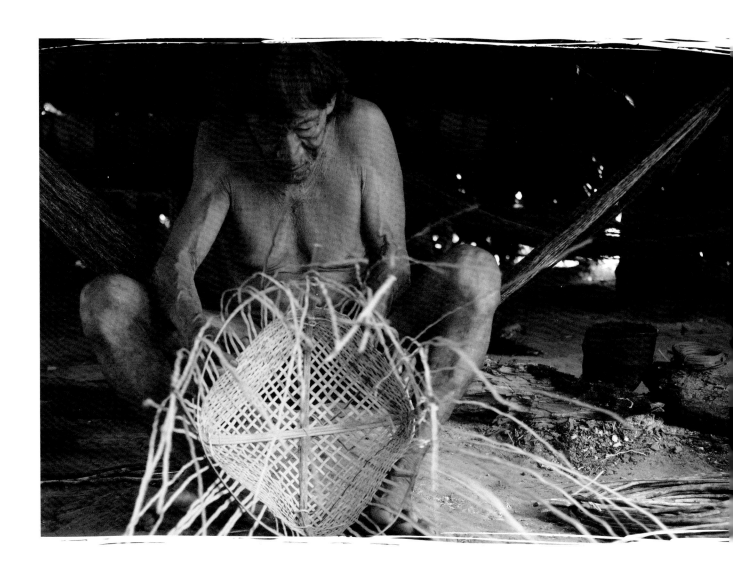

Gewa makes a split-vine basket in his home. Behind him is a coil of vine that has been dyed using a natural red dye, extracted from the wipita tree, to add pattern and colour to the basket. The opposite page shows an aerial view of a kapok tree, *Ceiba sp.*.

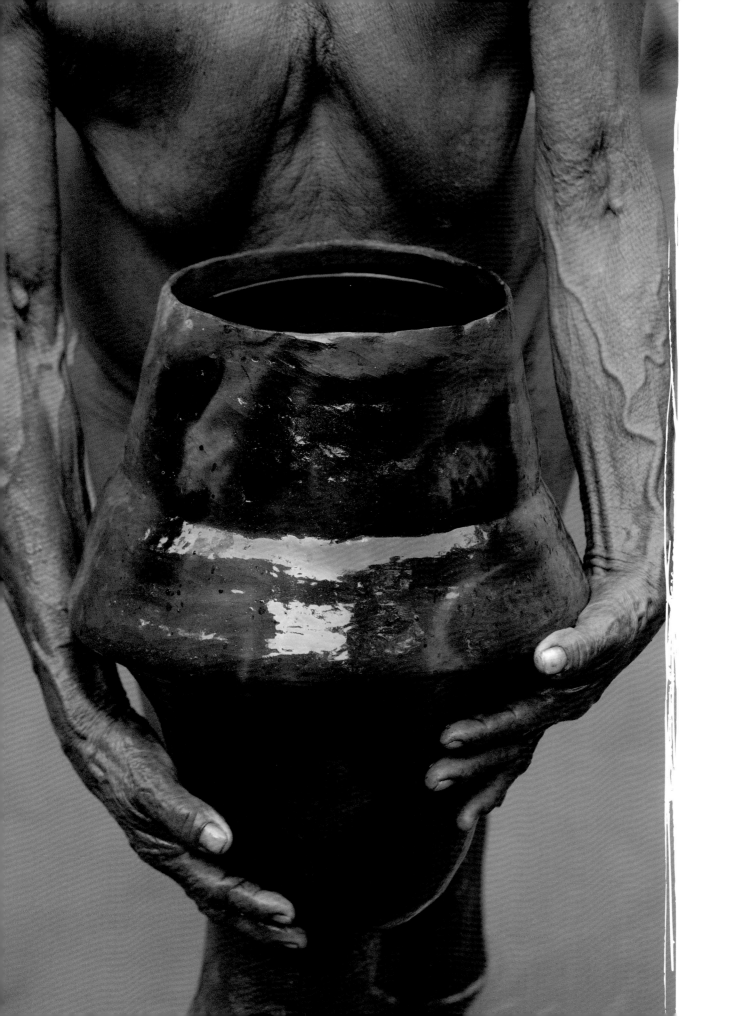

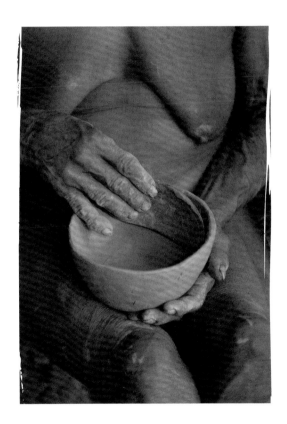

Huaorani pottery is shaped unlike any other pottery known in the Amazon. It is hand made from slender coils of rolled clay. The clay is usually found underwater on the banks of certain stretches of rivers. Only a few older women from some of the more traditional communities continue to make clay pots – they are largely being replaced by aluminum vessels.

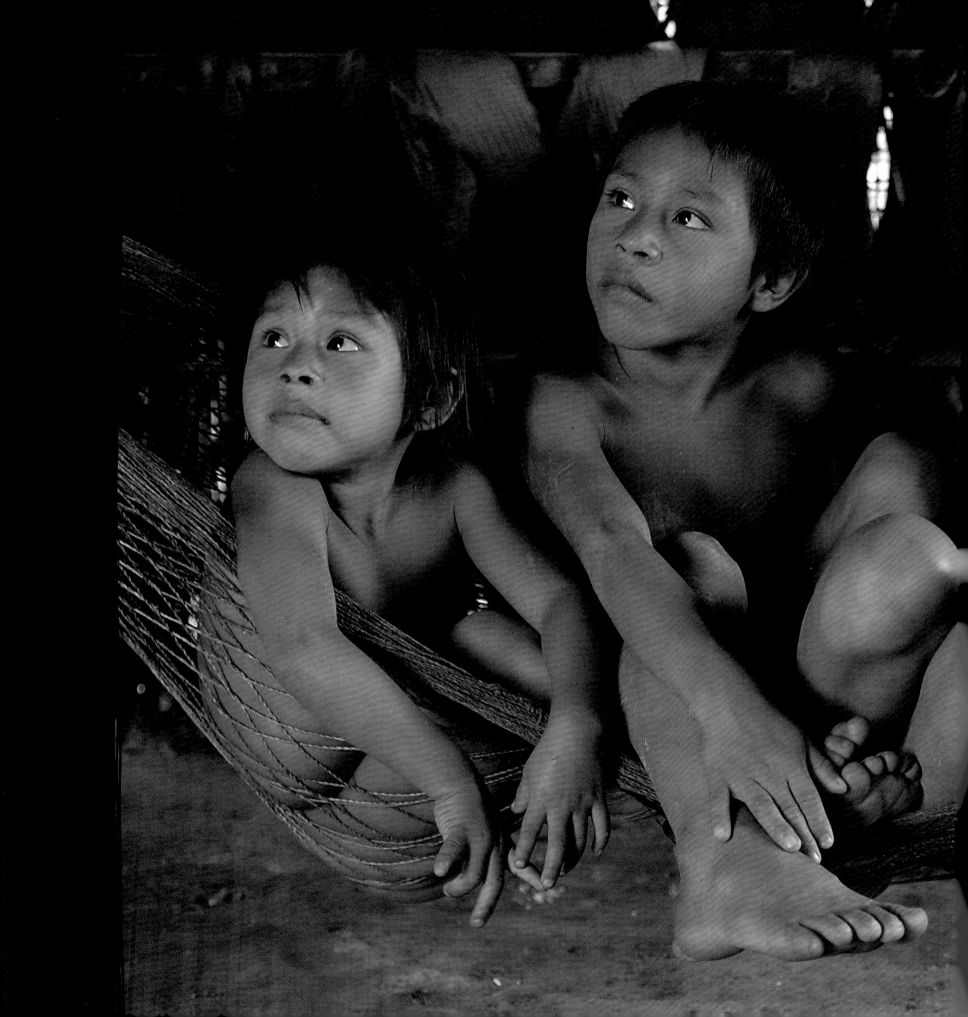

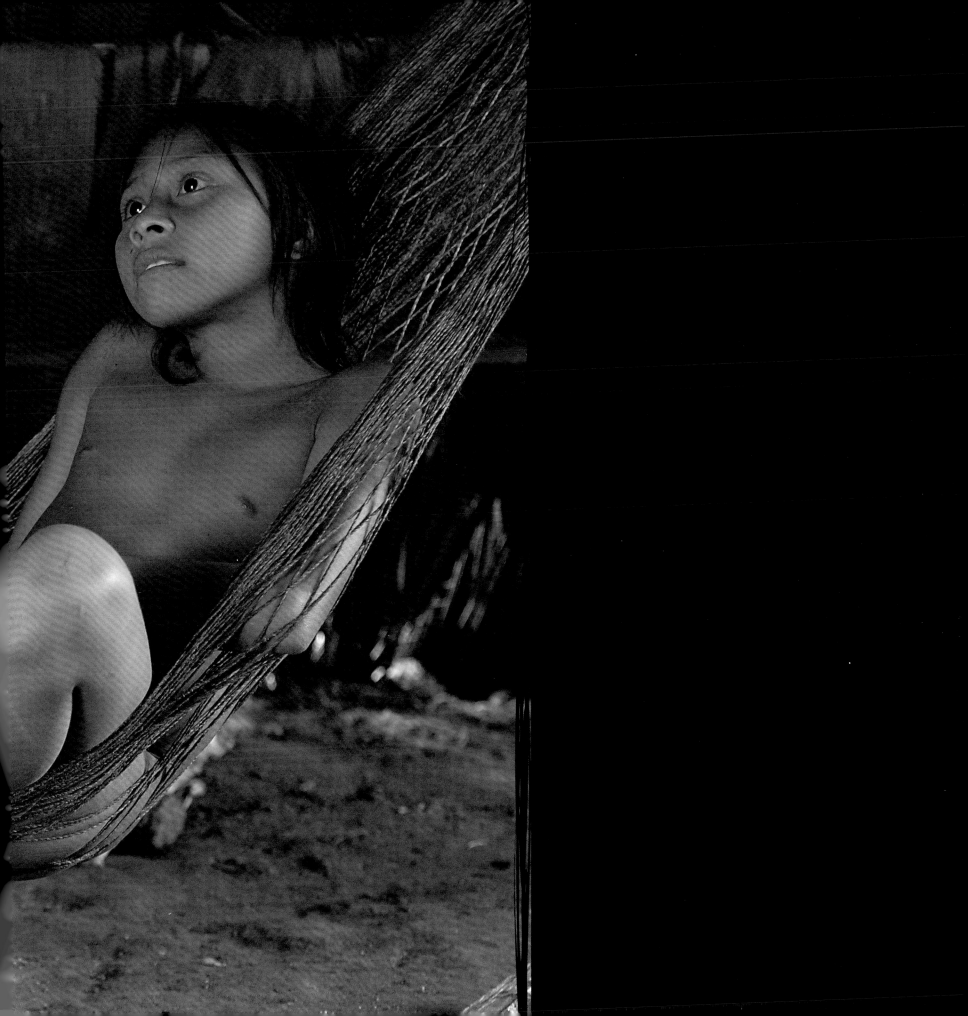

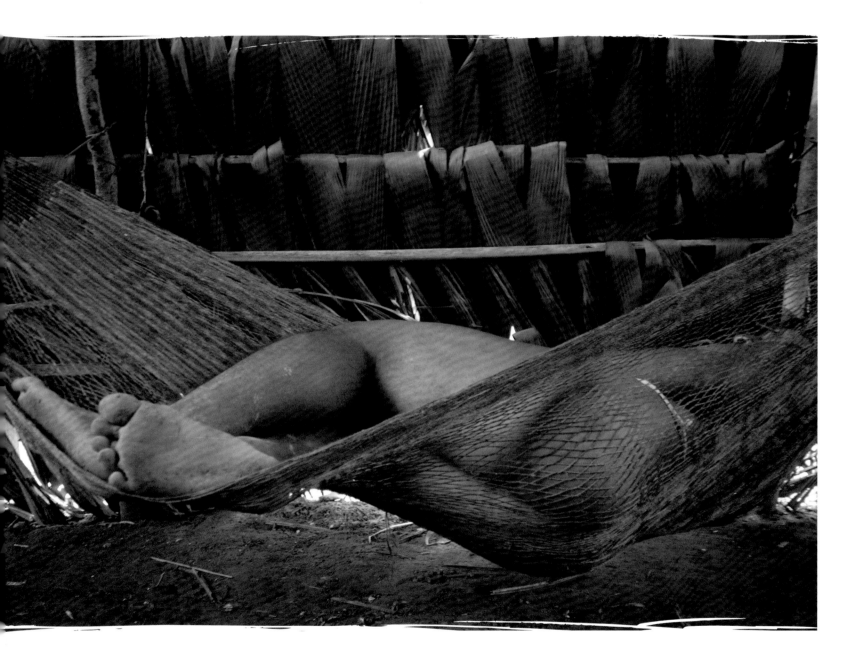

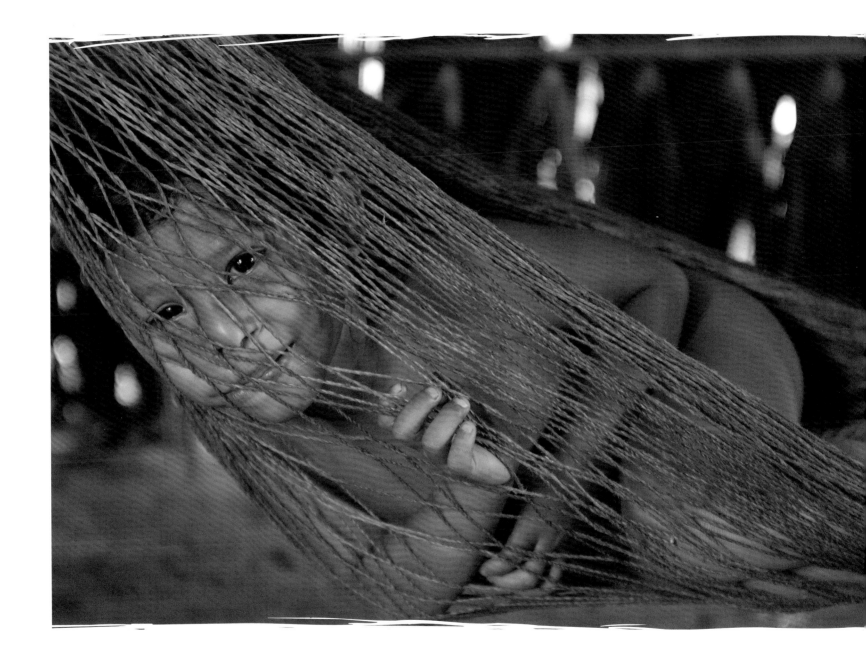

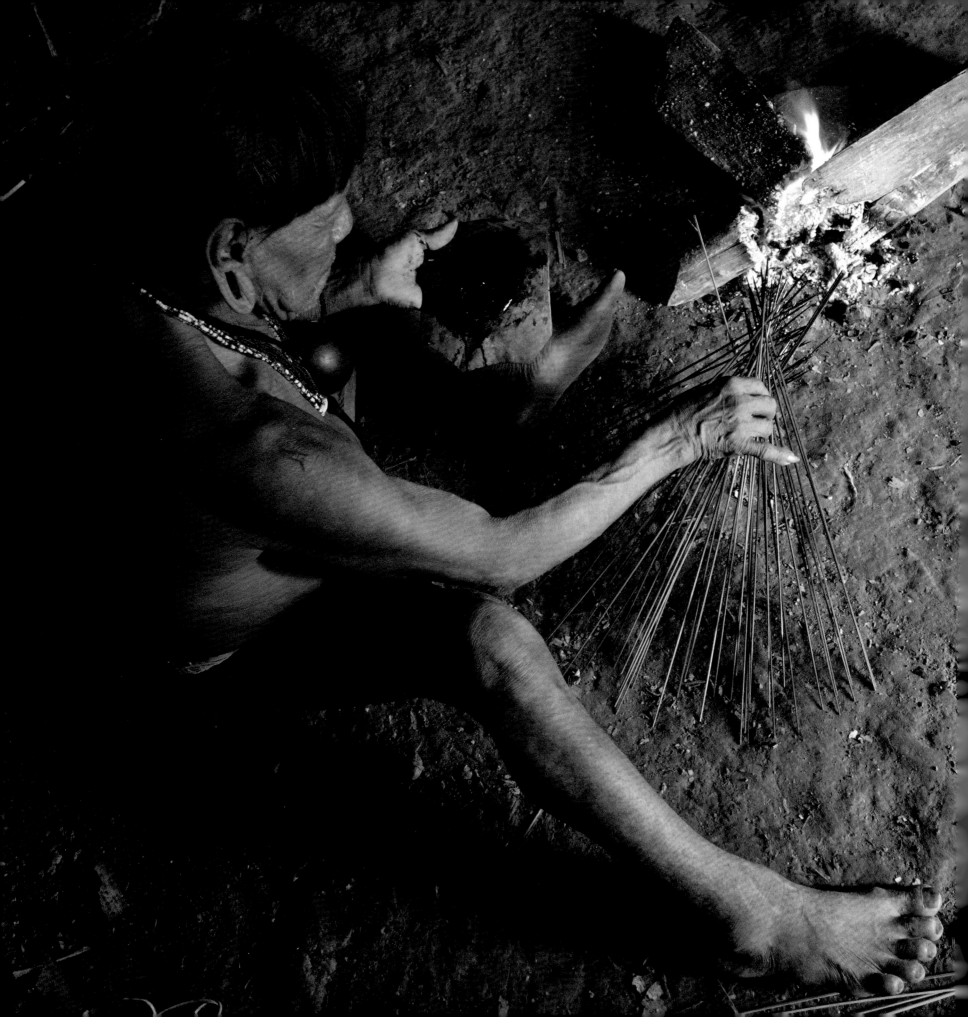

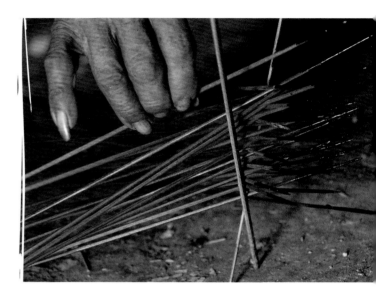

"A primitive people is not a backward or retarded people; indeed it may possess a genius for invention or action that leaves the achievements of civilized peoples far behind."

Claude Lévi-Strauss, The Savage Mind, *(1966)*.

Following a laborious process in which residue is extracted from the shavings of the *Strychnos toxifera* vine and later boiled down into a highly-poisonous, black tar-like substance, Kempere applies the curare poison to the tips of his blowgun darts, which are left to dry by the fire. Even today, *curare* is regarded as one of the most potent natural poisons known to Man.

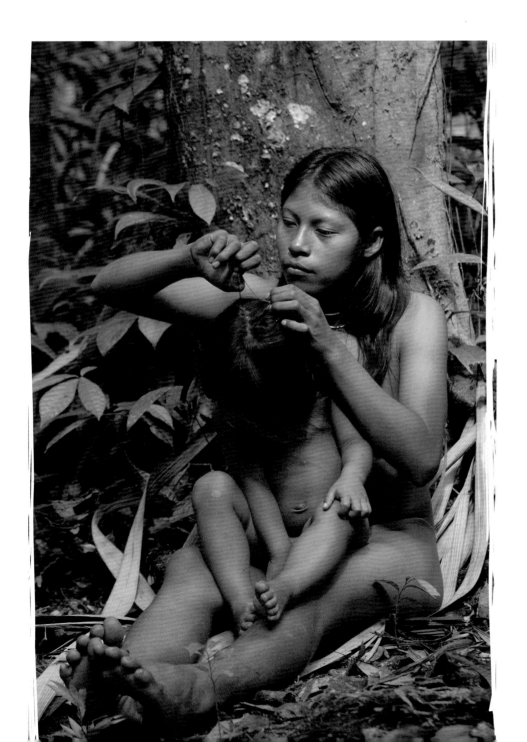

Carmen Kaiga relaxes in the forest picking nits from the head of a child.

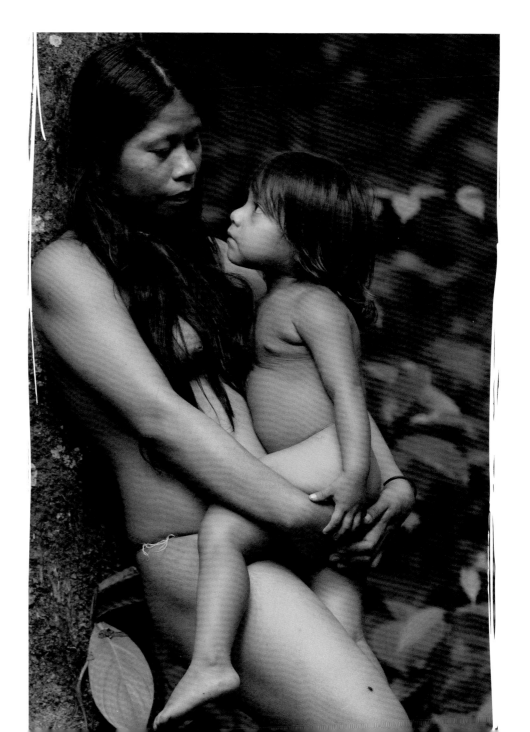

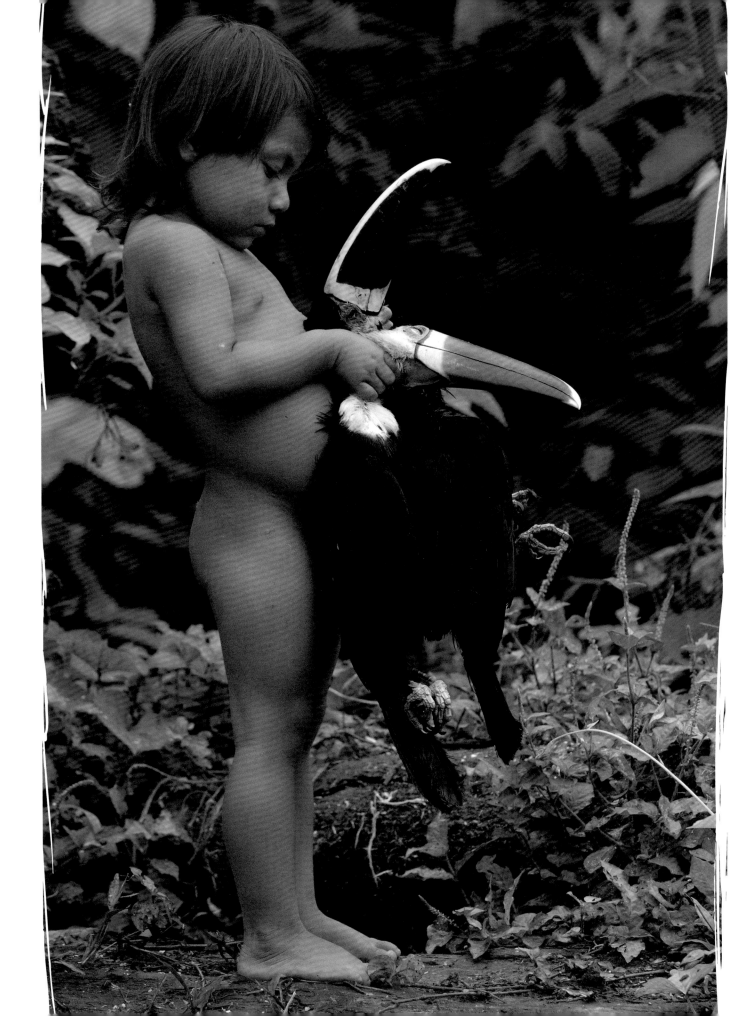

Two white-throated toucans, *Ramphastos tucanus*, killed for food. Although not producing much meat, many birds, including macaws, parrots and guans, are hunted.

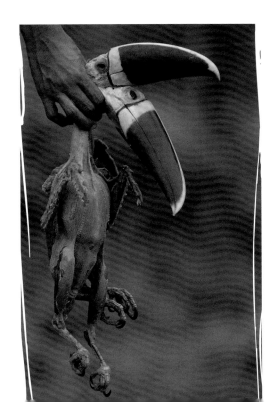

Huaorani households are normally full of pets, such as this night monkey, *Aotus vociferans*.
They may arrive as babies that fell from the trees still clinging to their hunted mothers.
Once tame, the pets usually roam free and may eventually even leave of their own accord.

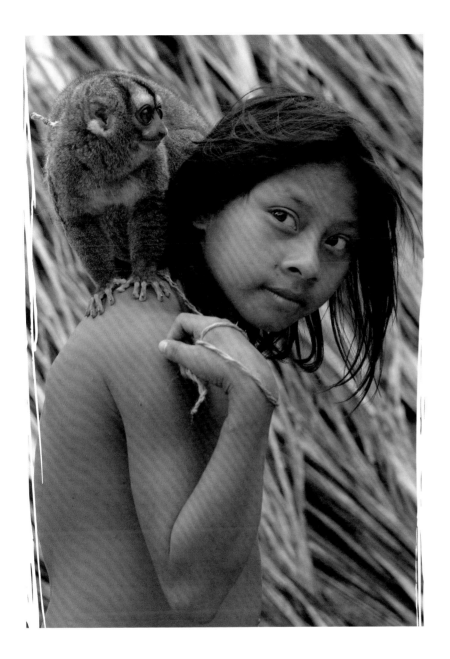
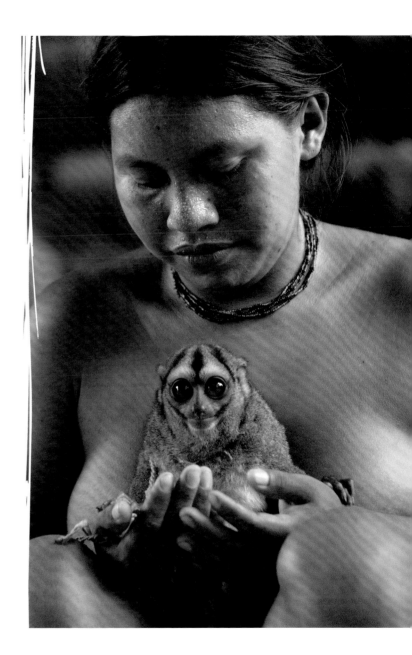

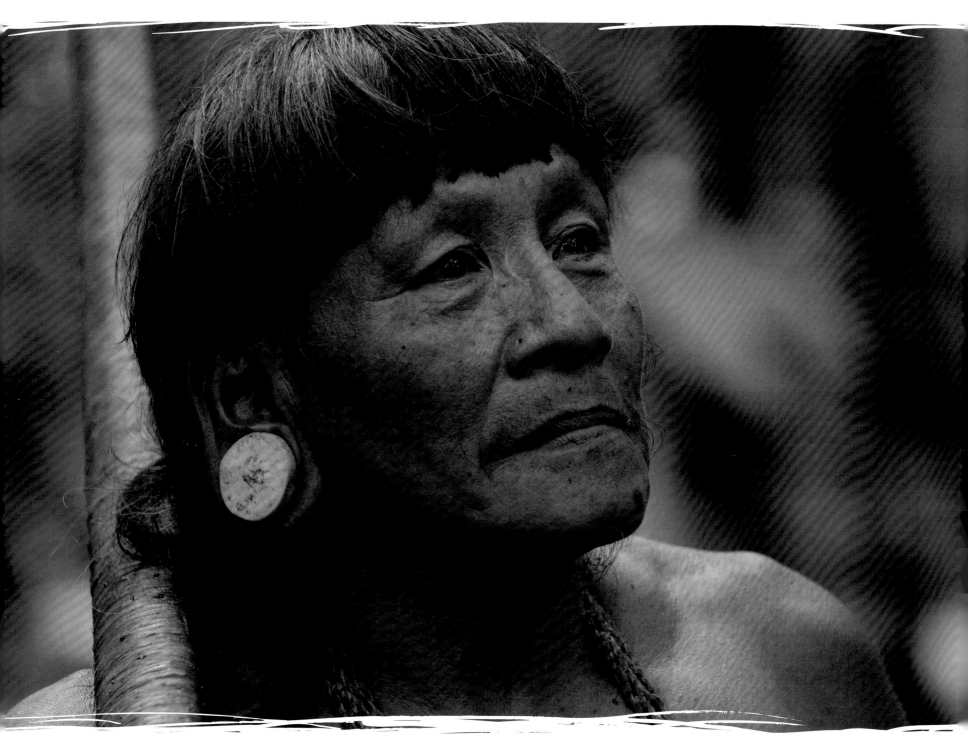

Both Menga (left) and Mipo have small holes pierced on either side of their noses. The Huaorani believe that when one of them dies the soul of the dead makes its way to heaven, where it encounters a huge boa obstructing the way. The boa first recognizes the holes in the extended ear lobes as belonging to a dead Huaorani and is encouraged to let the deceased pass. The snake is further convinced to allow passage upon recognizing the "pass holes" in the nose as well. Those poor souls that are not let through to heaven are doomed to return to Earth and live miserable lives as termites.

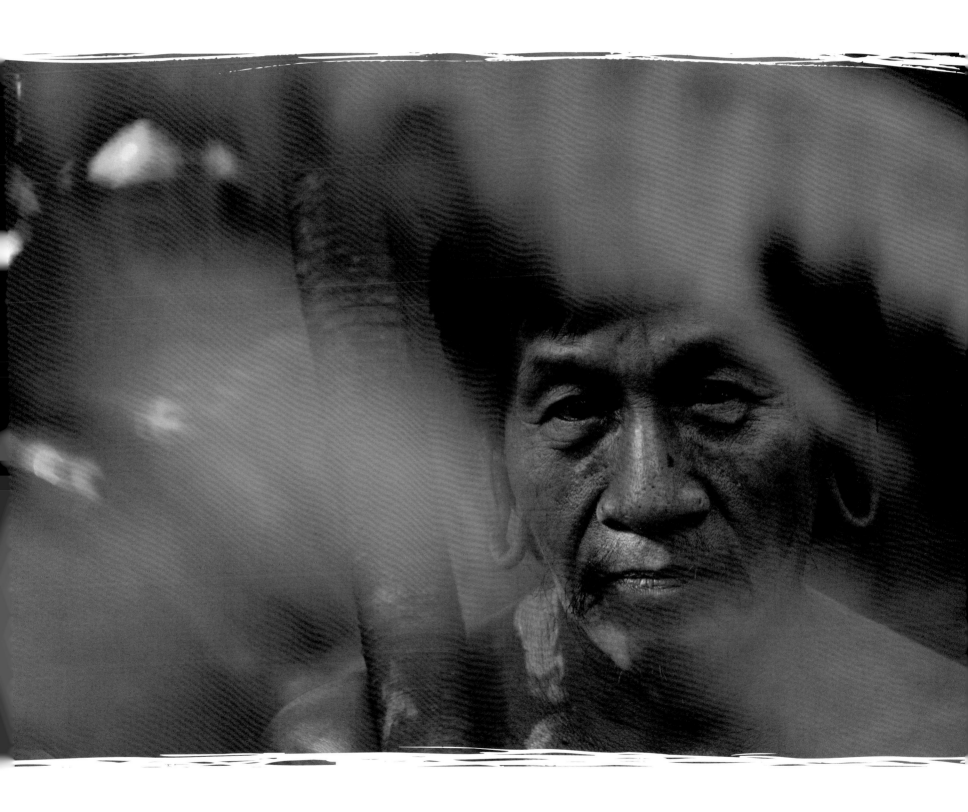

A hunted night monkey, *Aotus vociferans* (left) was killed to feed the pet harpy eagle while a dead squirrel monkey, *Saimiri sciureus* (below) is already in the clutches of the harpy's talons.
On the following page, Ewa Kemperi and Awame Gomoke from Bameno fish with *chambira* string nets for bait-fish that they pop into their mouths, still alive, as treats.

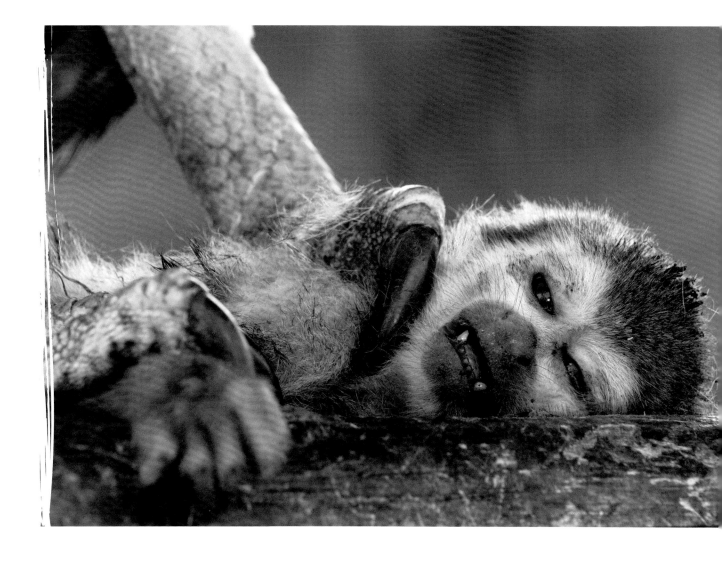

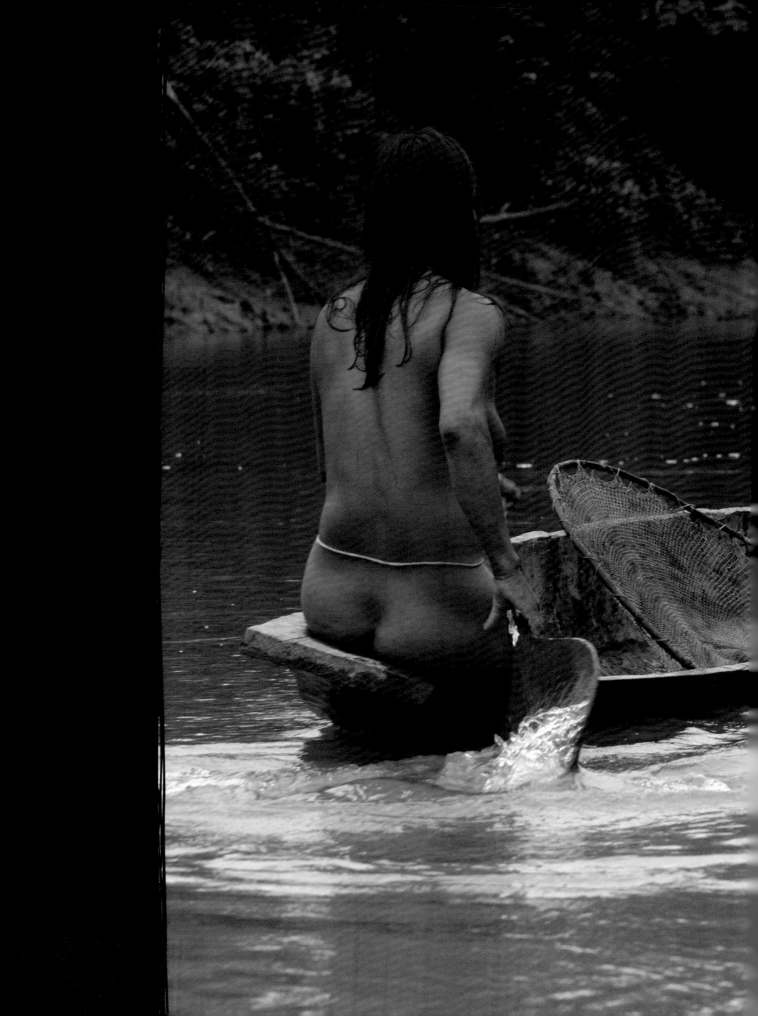

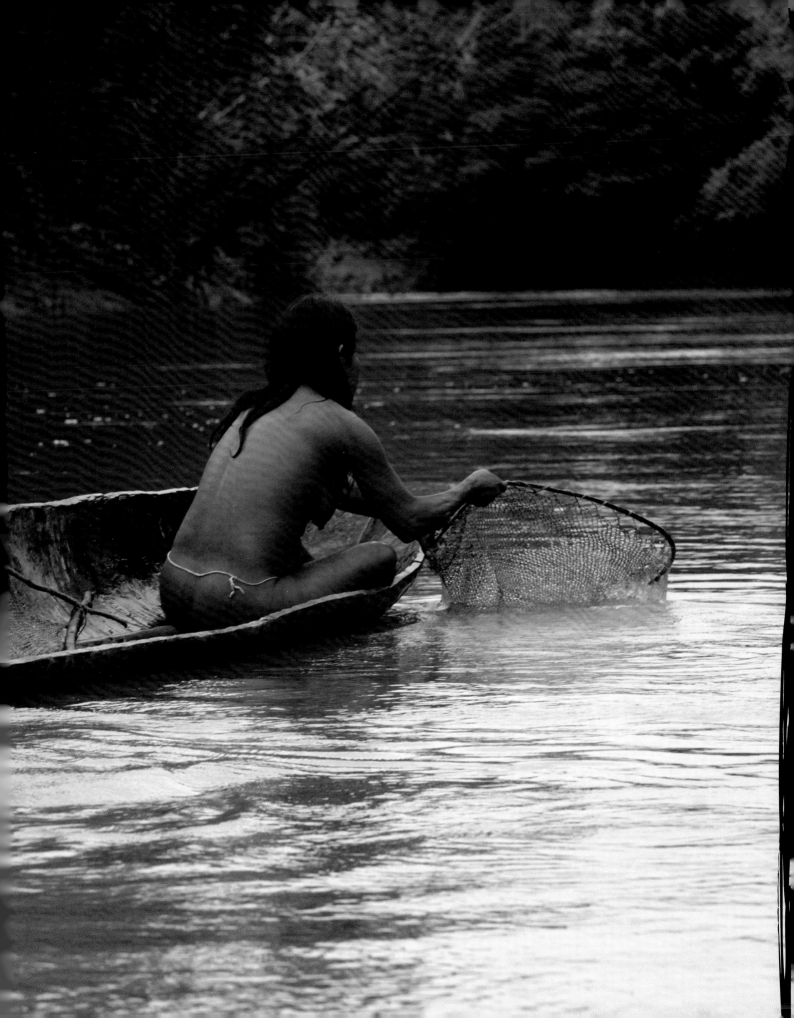

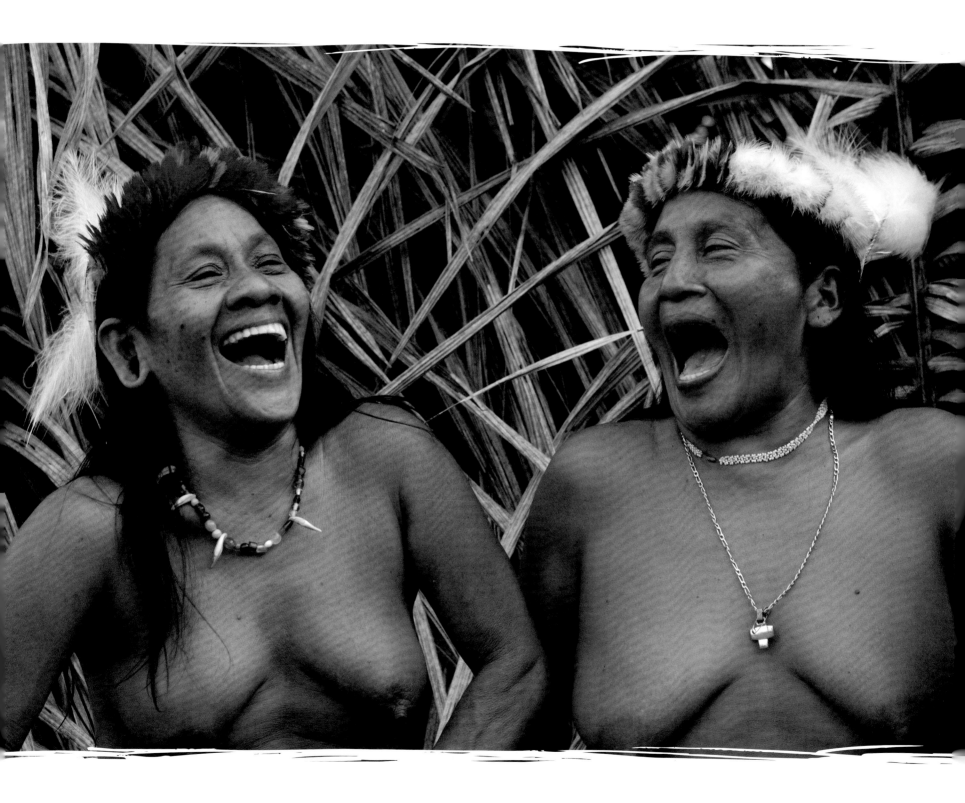

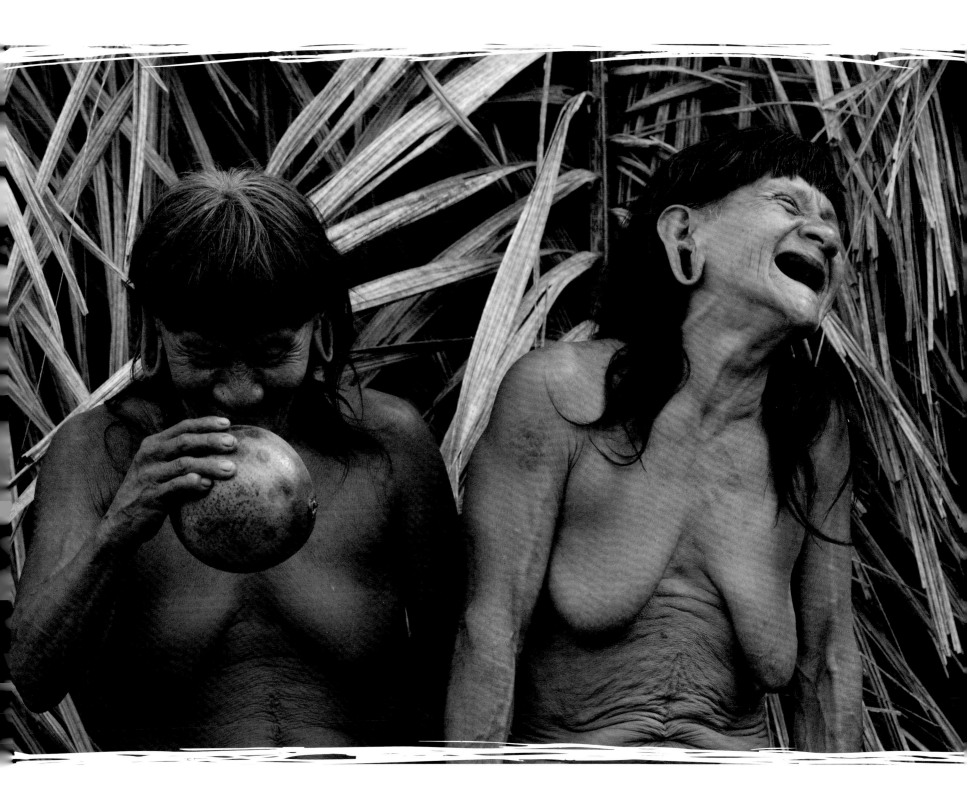

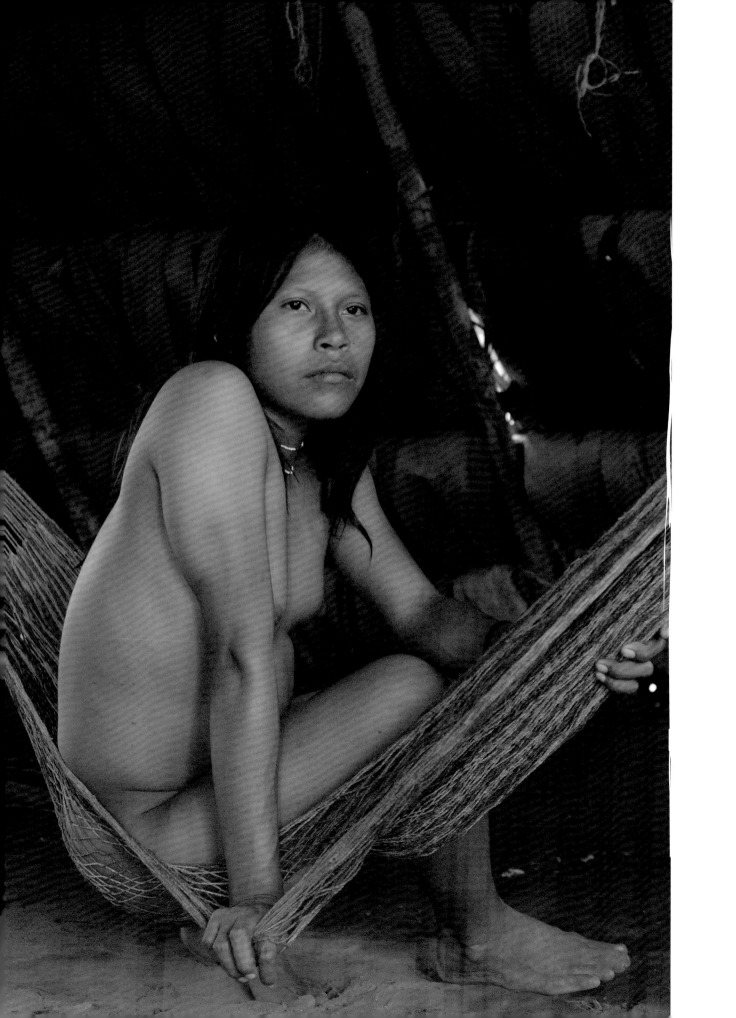

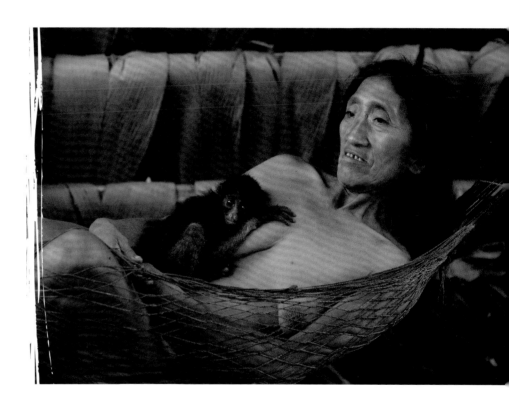

Kano rests in her hammock with a pet baby spider monkey,
Ateles belzebuth, which lives untethered in and around the hut.

"He who would travel happily must travel light."

Antoine de Saint-Exupery, author and aviator (1900-1945).

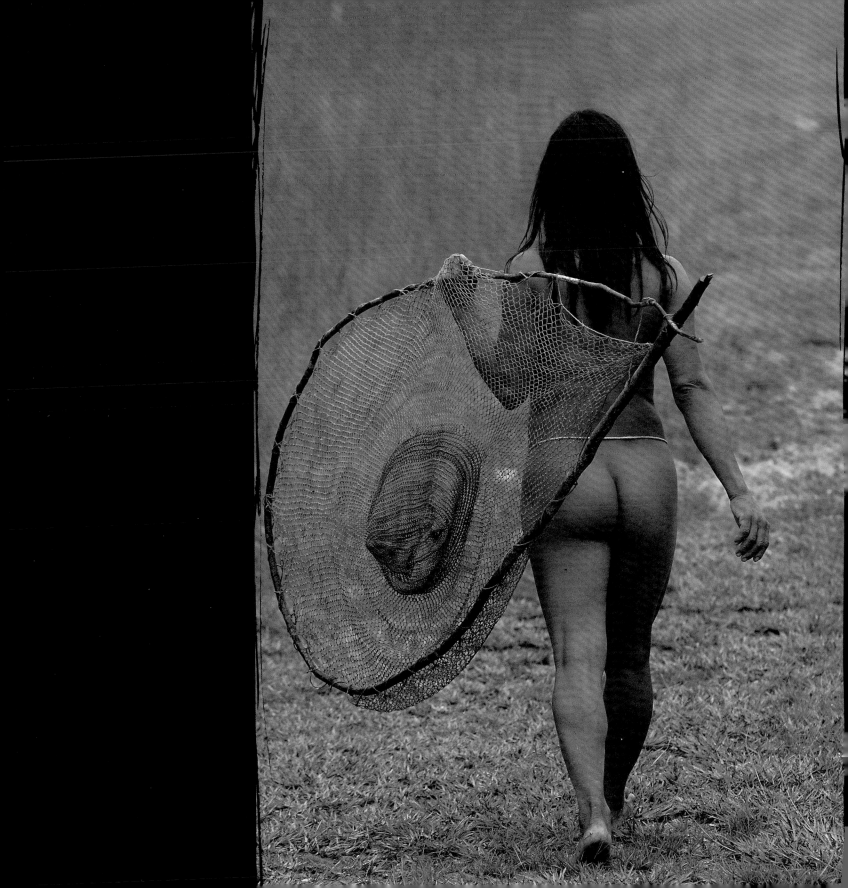

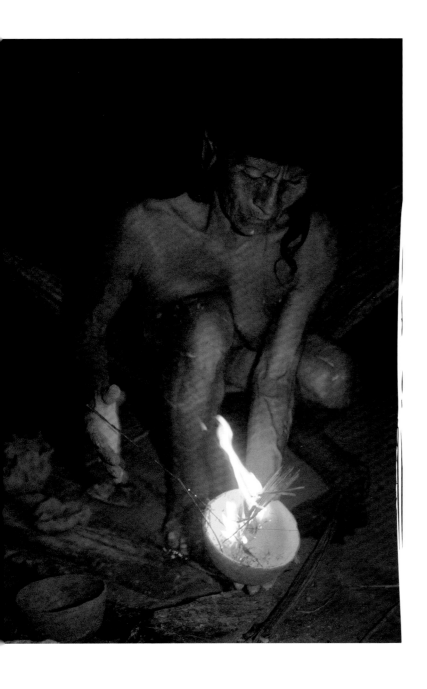

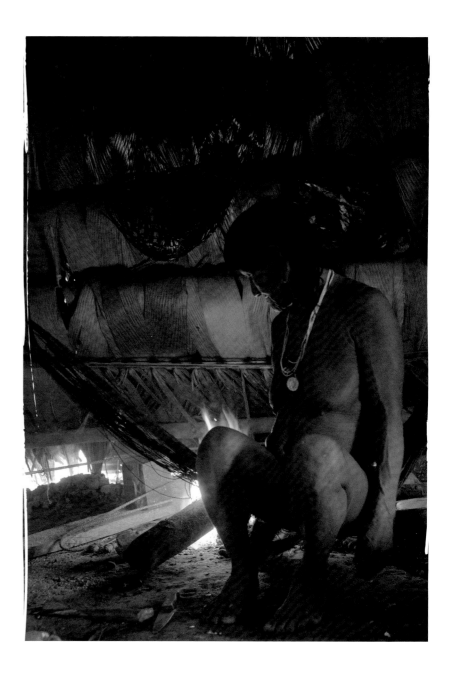

Using fire, Dabe sears the inside of a freshly crafted clay bowl.

"We live in an age when unnecessary things are our only necessities."

Oscar Wilde.

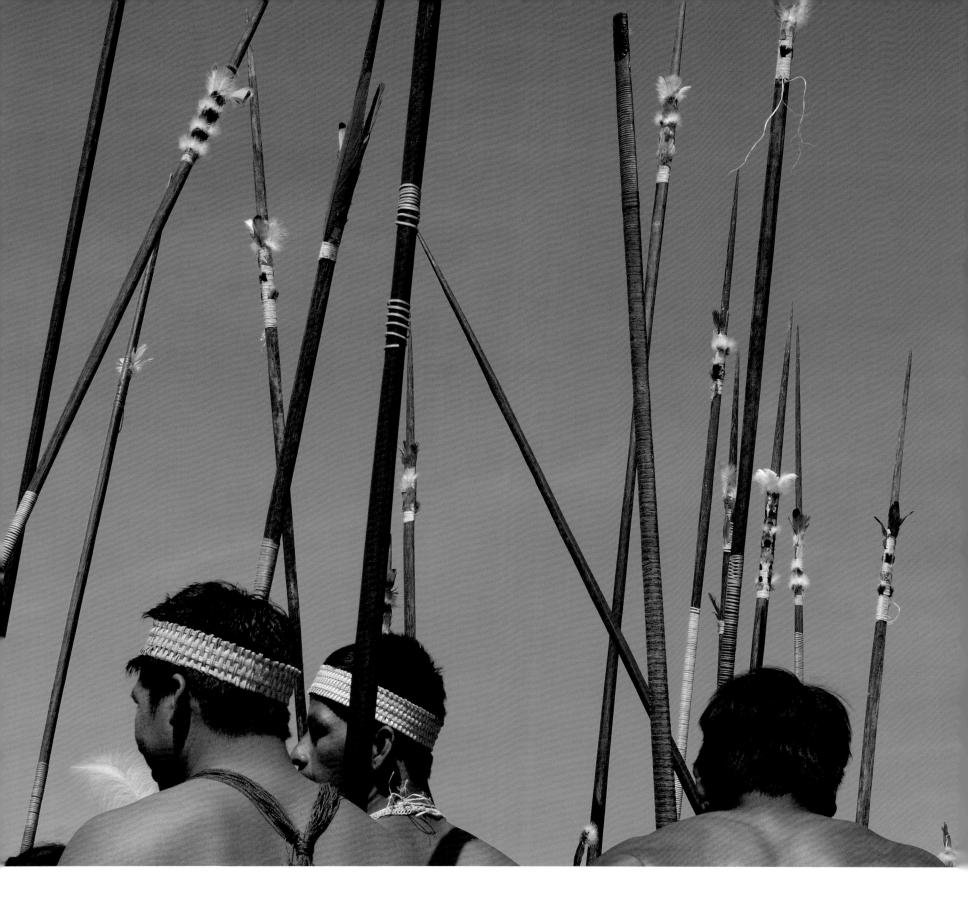

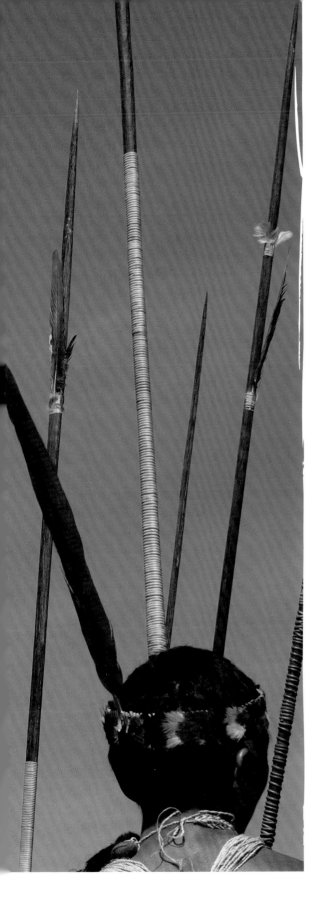

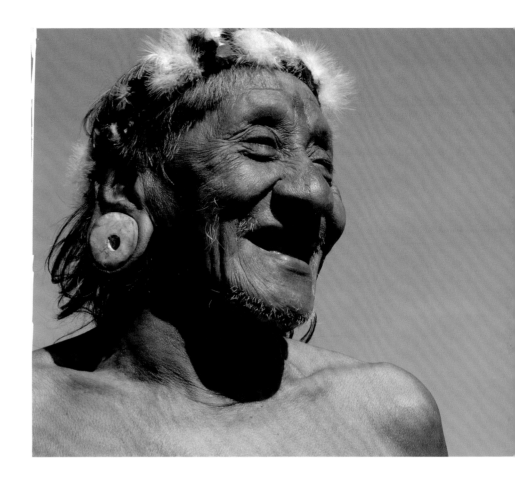

"I have found that I can trust these people whom we call 'savage' more and feel safer among them than among insincere, decadent people in many parts of France."

Jean de Lery.

As Meñewa returns home with a peccary, women come out both to greet him and to pay homage to the prey.

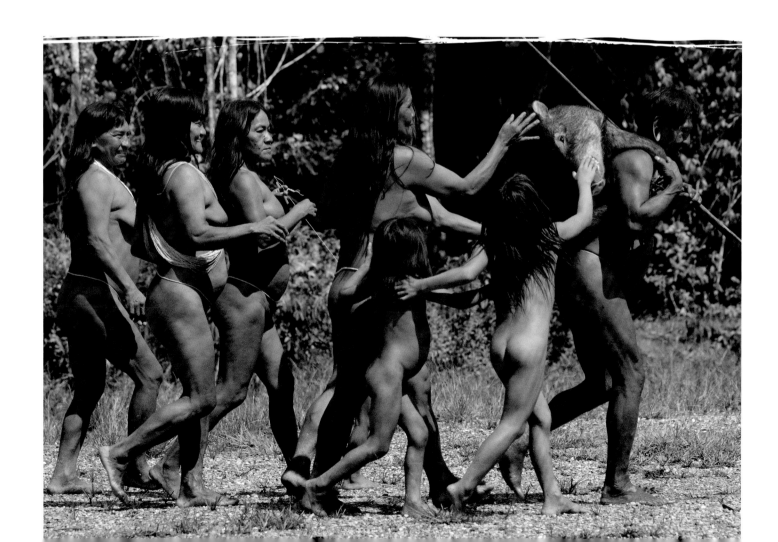

The Huaorani are not very fecund. They recognize that resources are limited. They have learnt forms of contraception using native plants and will still practice infanticide, especially if the baby is a daughter when the mother already has a daughter.

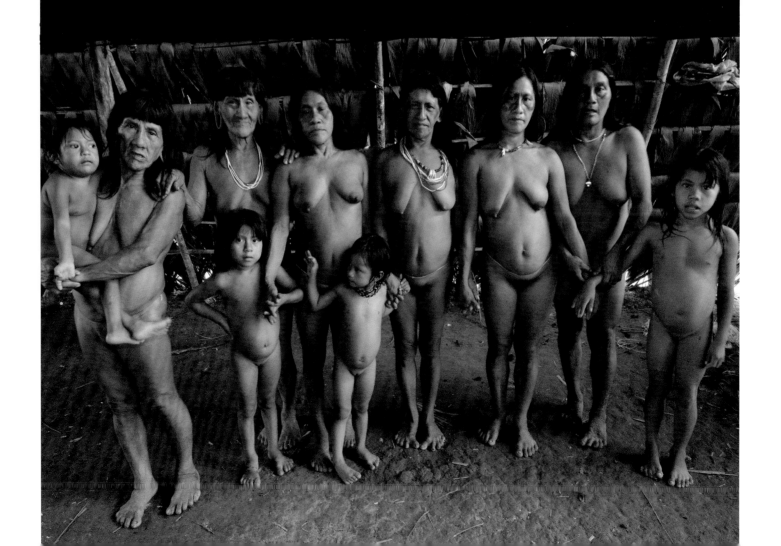

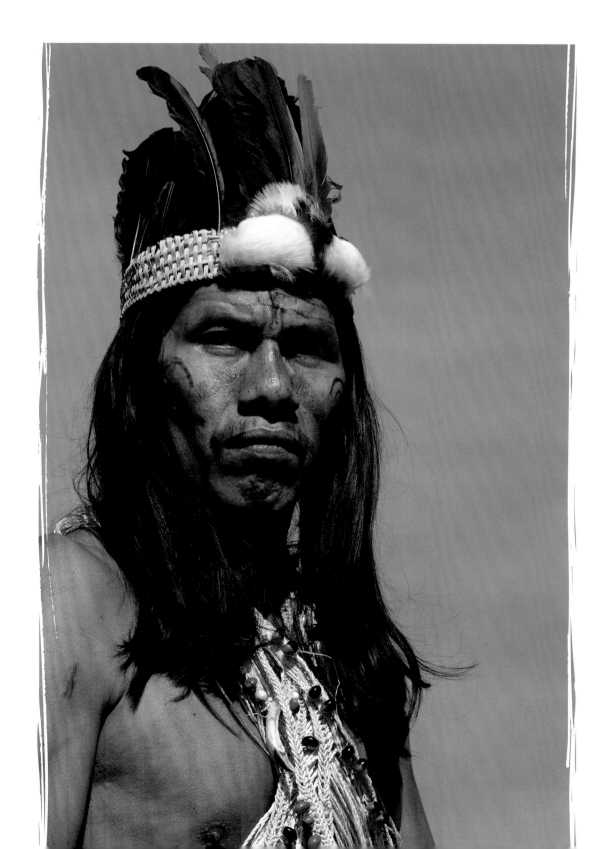

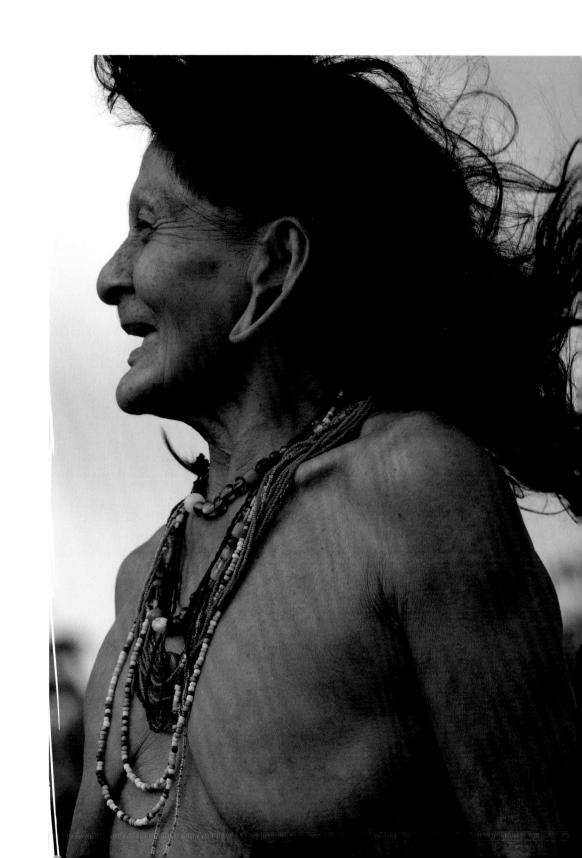

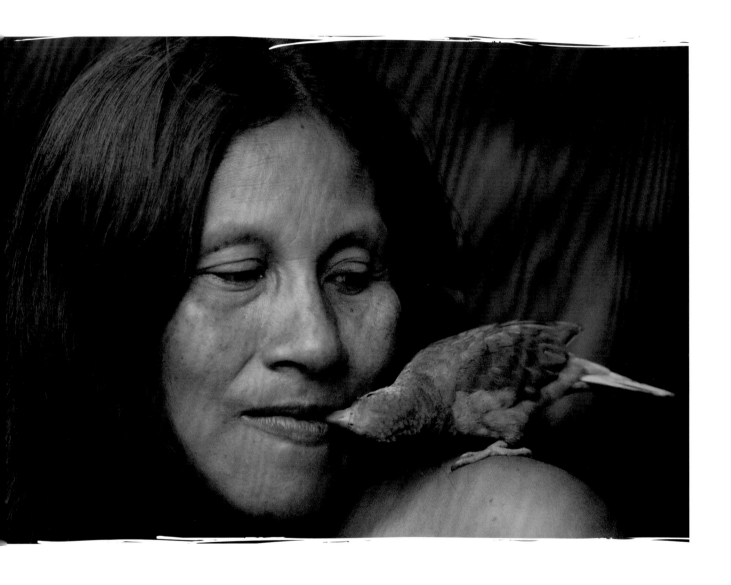

Wenyeya feeds her pet cobalt-winged parakeet, *Brotogeris cyanoptera*, from her mouth, a common practice amongst Huaorani.

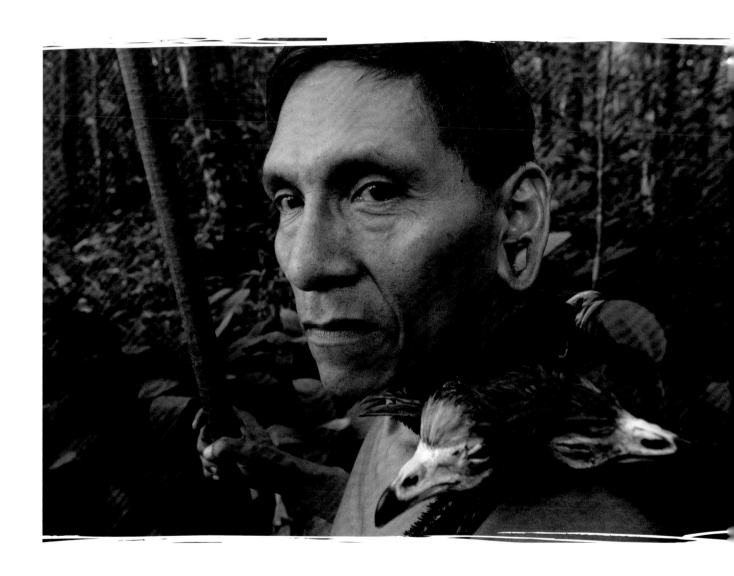

Tage returns home with two common piping-guans, *Pipile pipile*, and two gray-winged trumpeters, *Psophia crepitans*, both species with relatively high meat content.

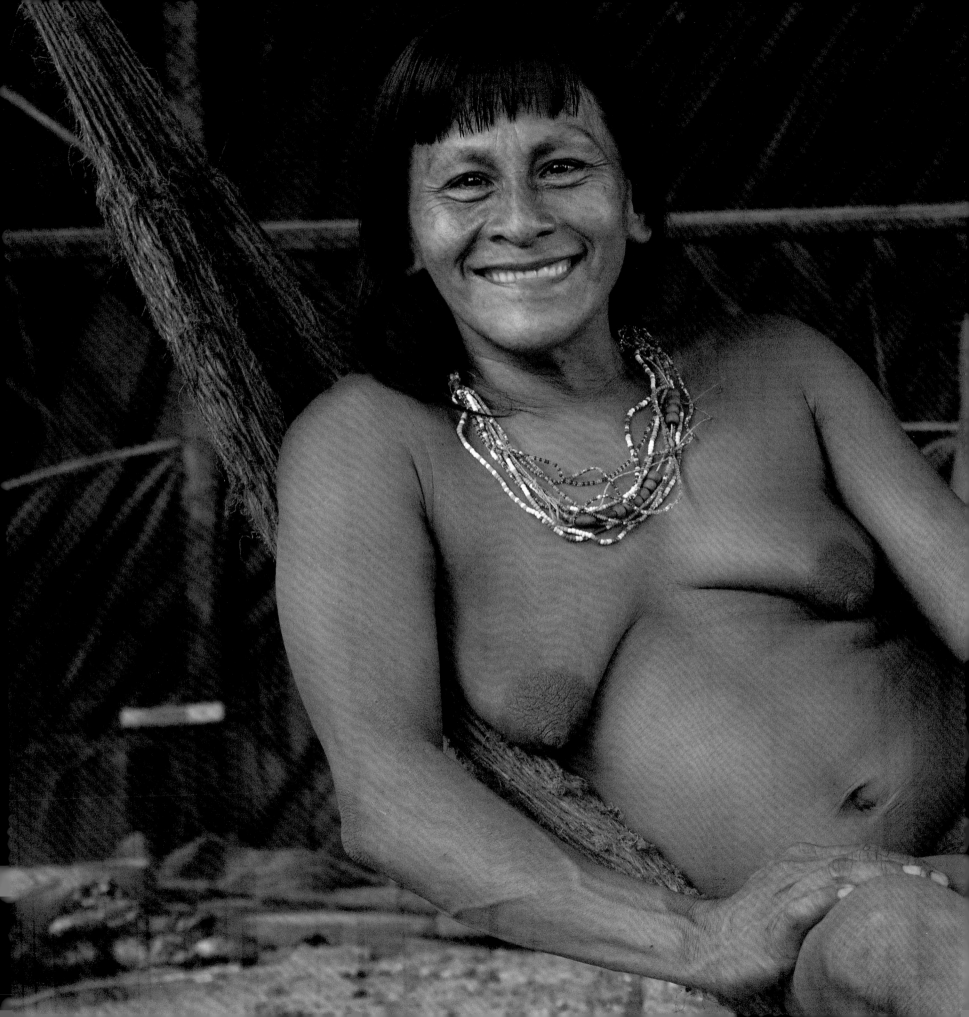

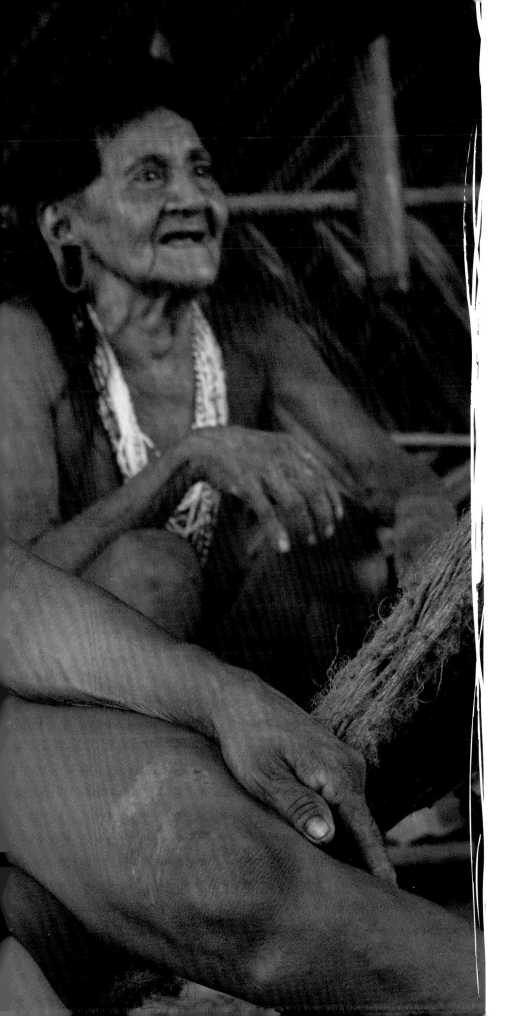

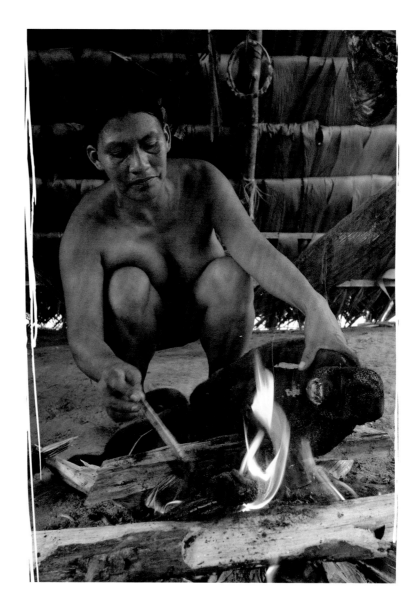

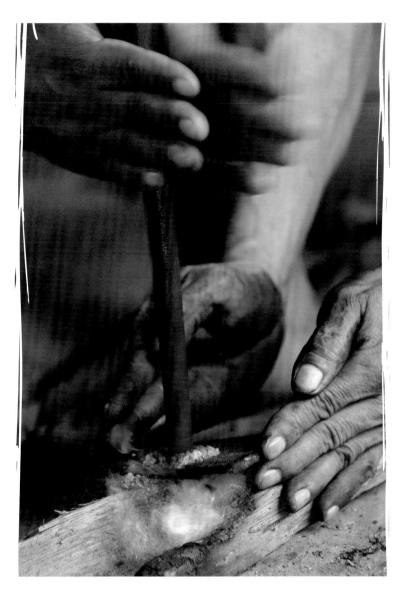

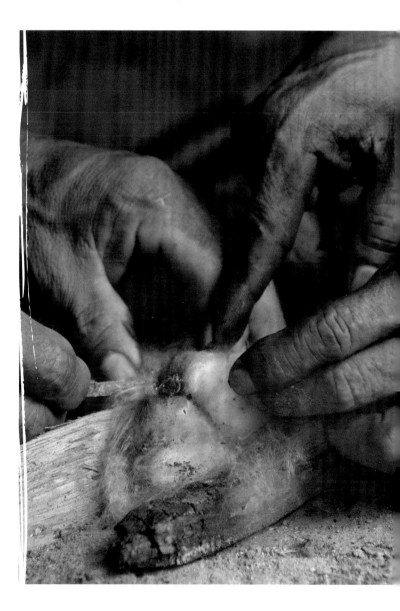

Fire is essential to Huaorani daily life. Here one monkey, the pet, warms himself in the early morning, while another, the meal, has his fur singed before being butchered. In order to make fire in the traditional way, a hardwood spindle is spun between the hands in a rubbing motion. The friction of the moving tip, as it rotates in a socket of a hardwood base, causes enough heat to ignite wool from the kapok tree and hence start a fire.

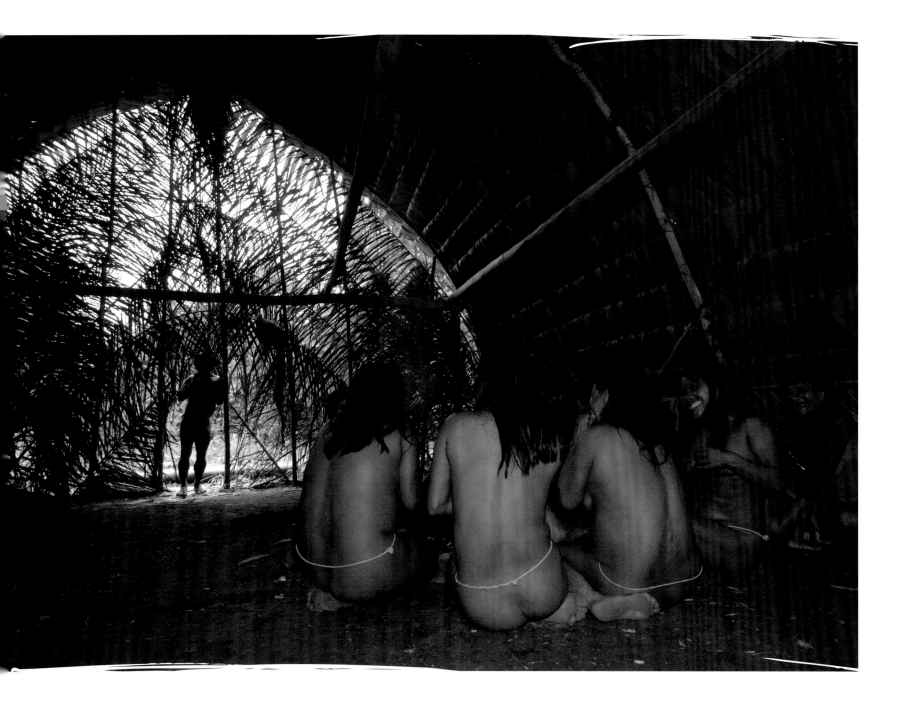

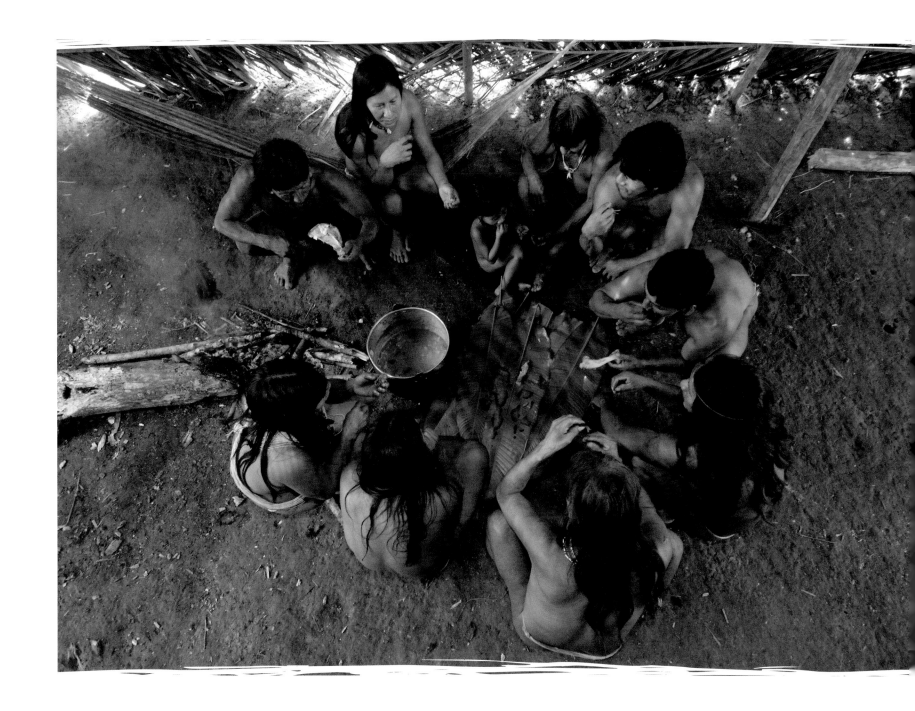

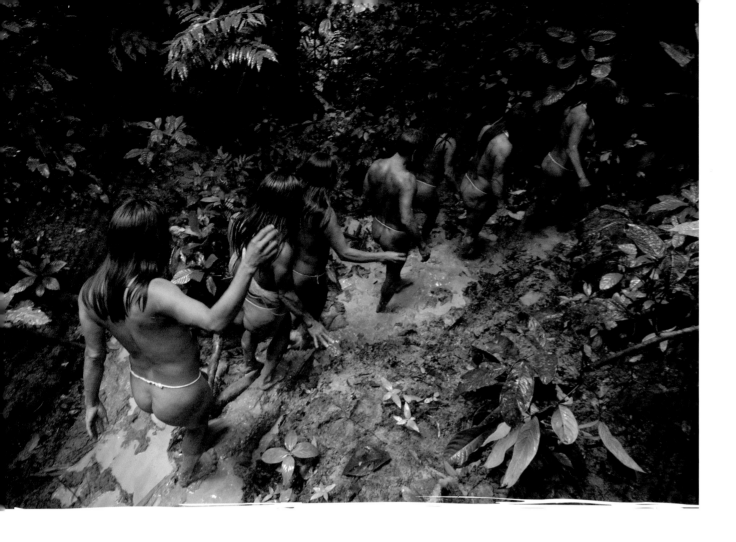

"The clearest way into the universe is through a forest wilderness."

John Muir (1838-1914) Scottish-born American naturalist.

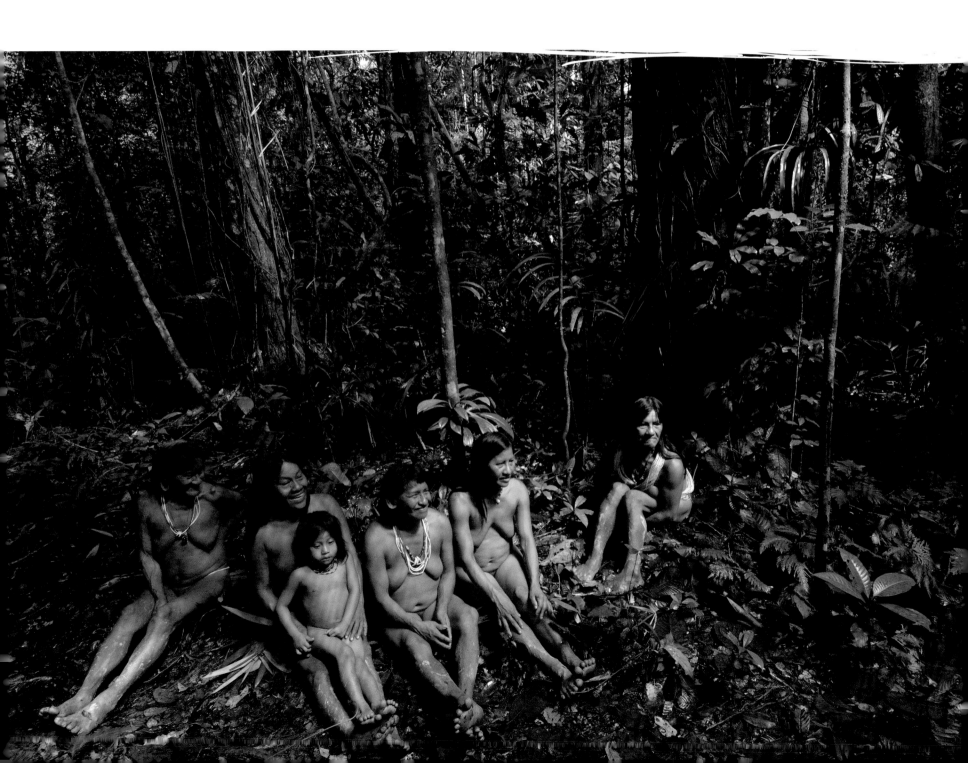

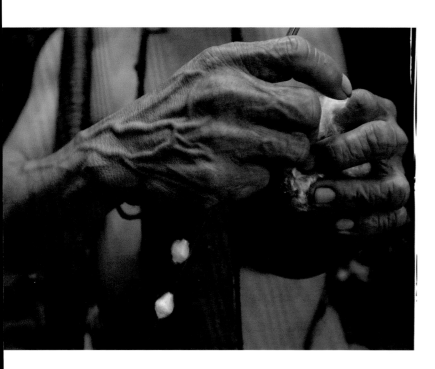

A small tuft of cotton from the kapok tree is wrapped around the dart to plug the barrel of the blowgun. This effectively forms a seal against which the force of the blow expels the dart.

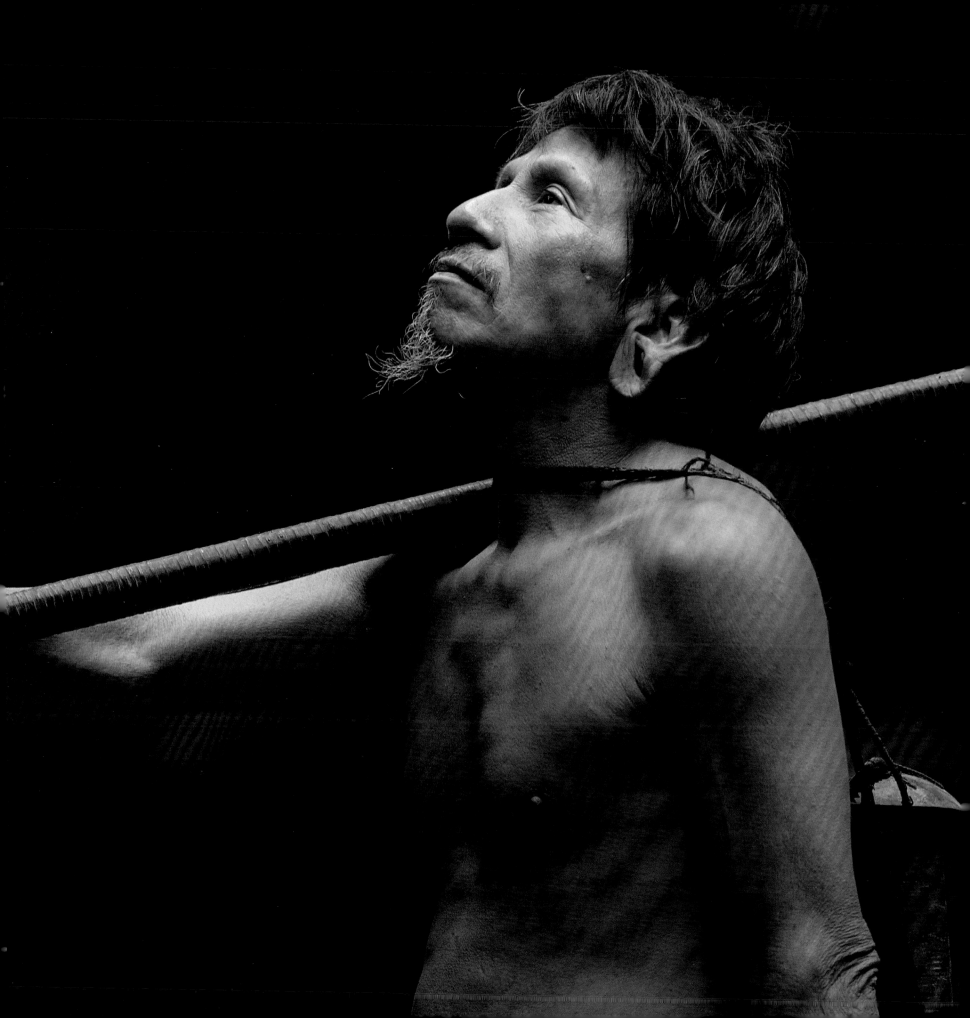

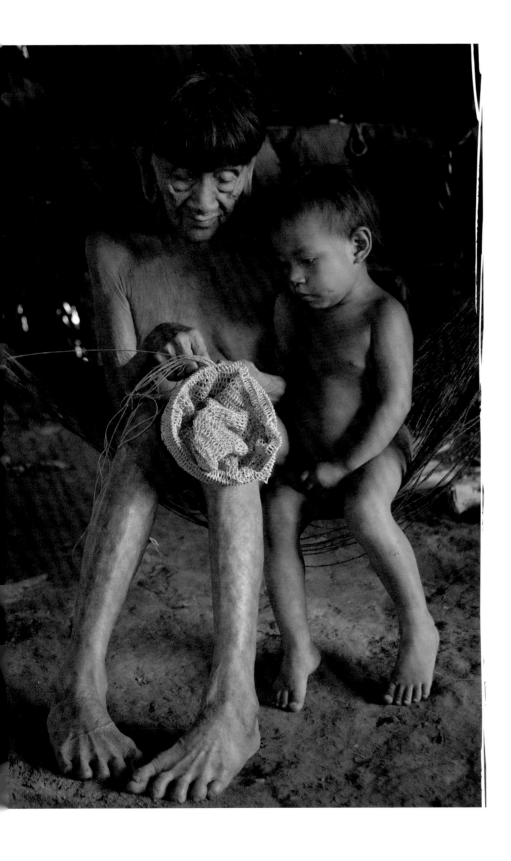

Dexterity and artisanal skills are learned early in a Huaorani community, where education is typically informal. Here, a young child learns by observation from Konta how to weave a *chambira* palm string bag.

Meanwhile in the forest, a carrying bag to be used just once is woven from two palm leaves in no more than a couple of minutes.

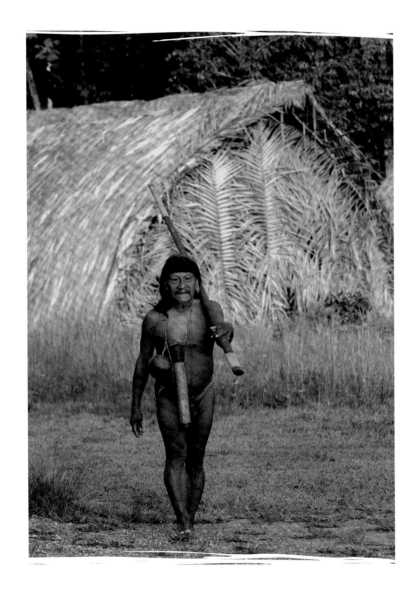

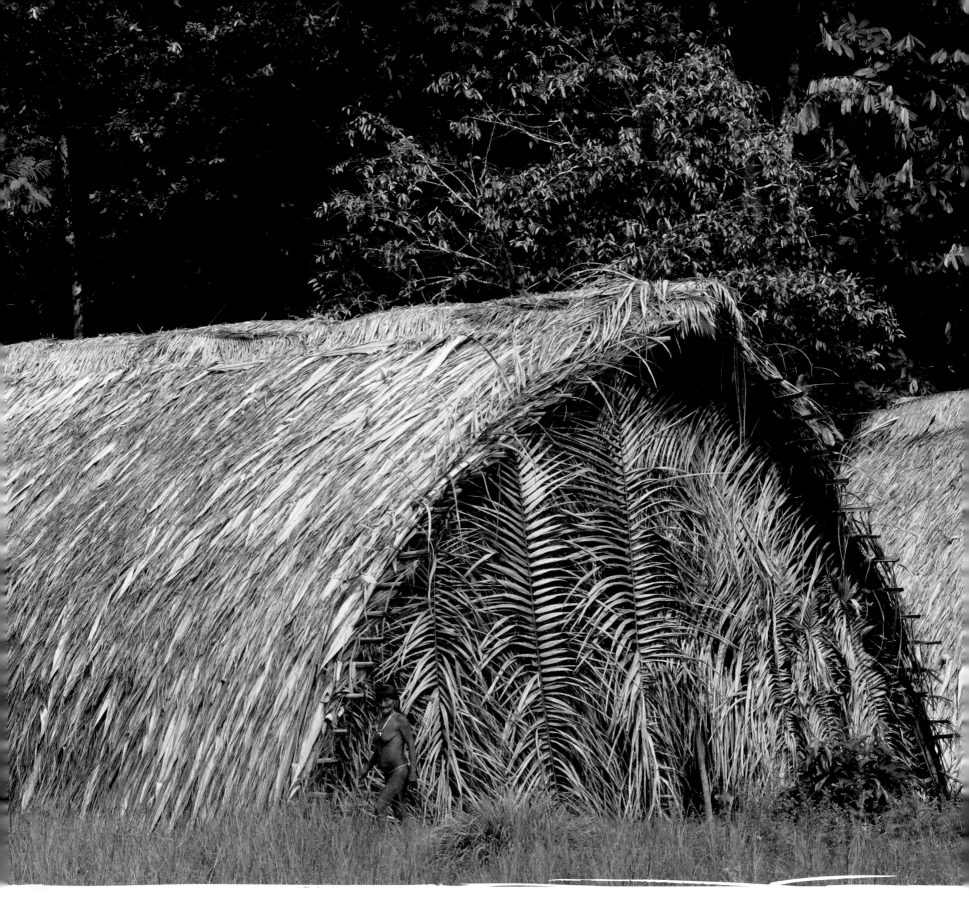

A traditional Huaorani house is huge, dark, cool and cozy. It is made from a thatch of palm leaves tied over a curved frame. There are two entrance slits between the palm fronds, one at each end of the hut.

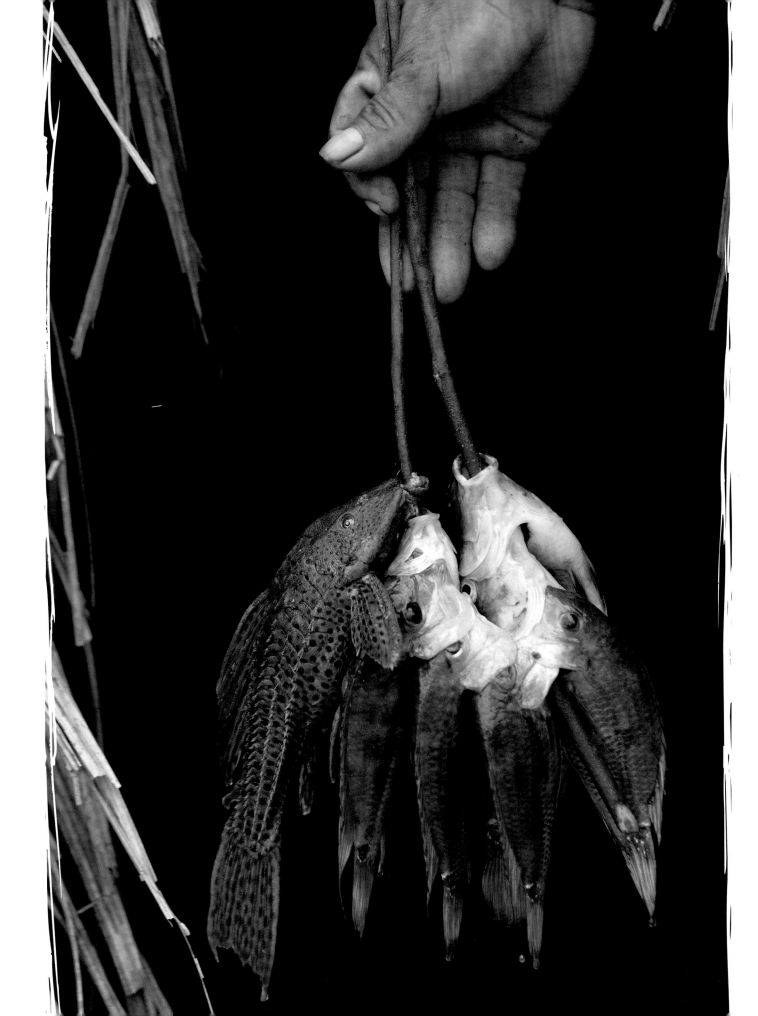

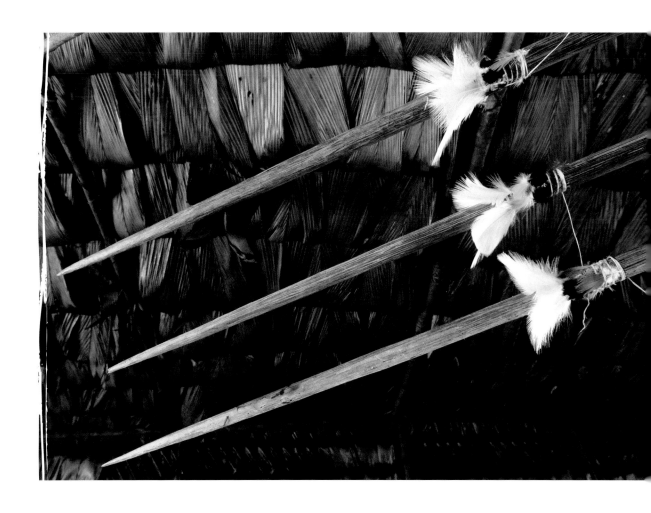

Huaorani lances are formidable weapons in a hunter or warrior's hands. They are made from the extremely hard and straight-grained chonta palm, *Bactris gaspaes*. The design of the decorative feathers is individually-recognisable.

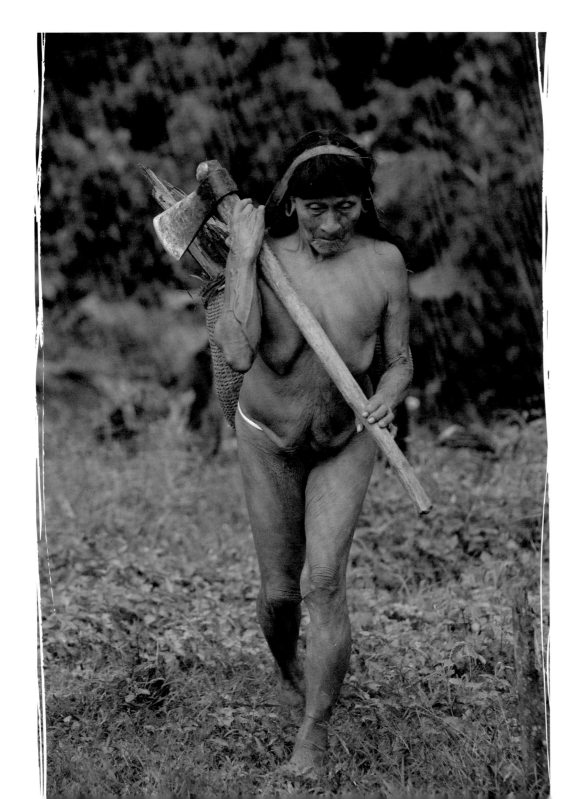

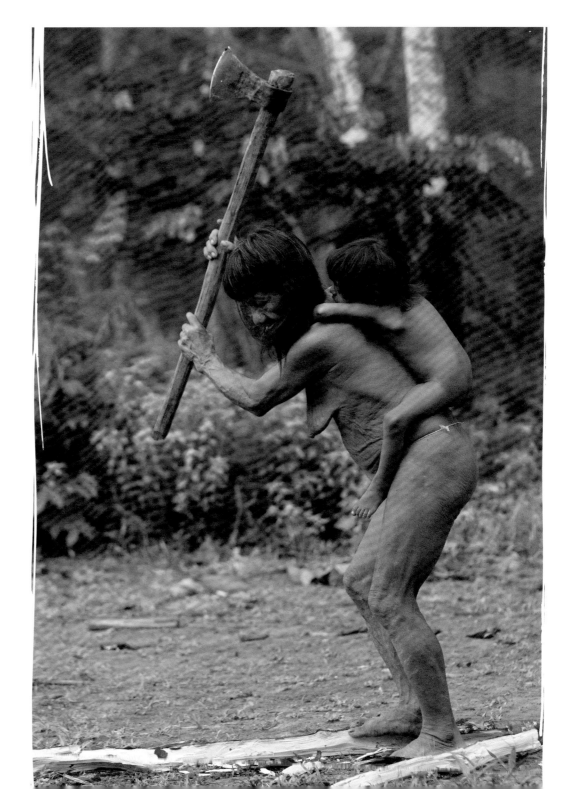

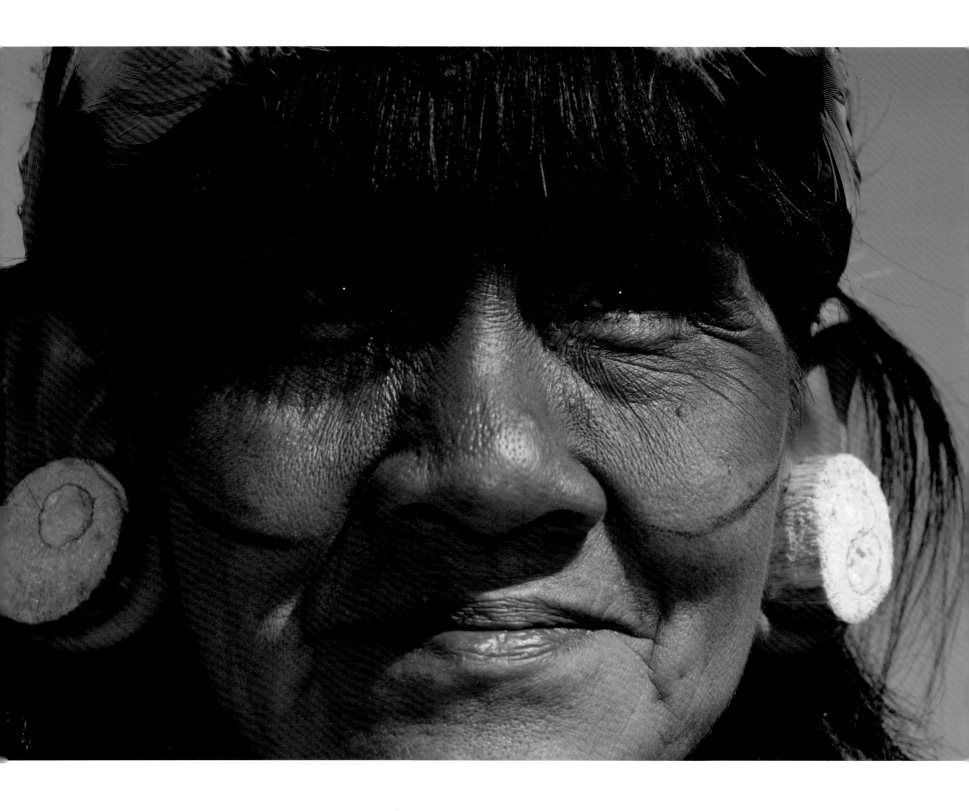

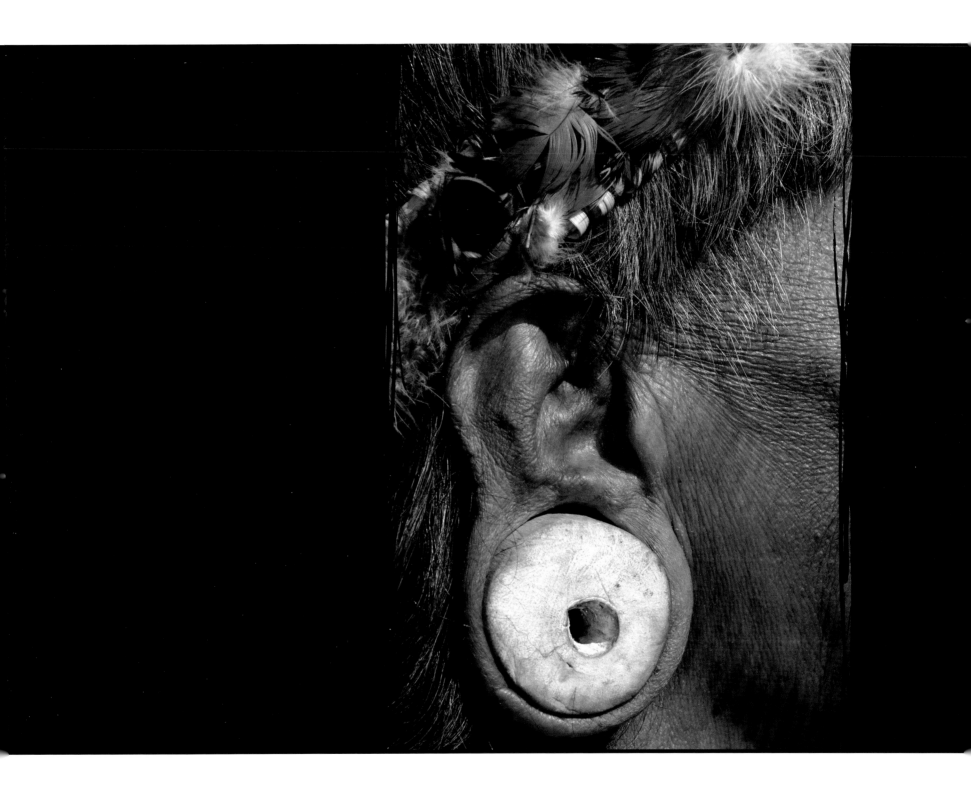

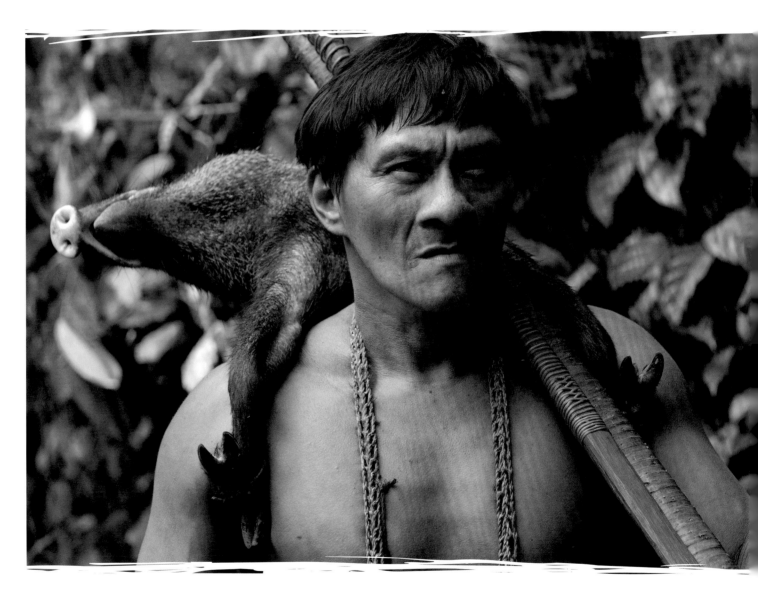

Ontogamo brings home a collared peccary, *Pecari tajacu*, which he has trussed with vines to be able to wear as a backpack. Meanwhile Romelia climbs onto a white-lipped peccary, *Tayassu pecari*, which has had its guts removed by the hunter in order to lighten the heavy load on his three-hour walk home. She looks for ticks to pull off as a source of amusement.

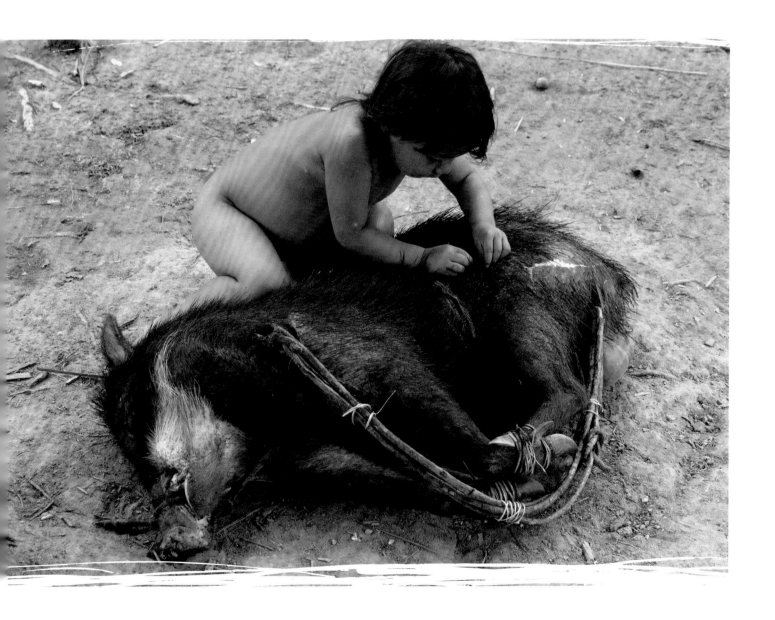

A peccary is butchered after its hair has first been singed off over an open fire (below).
Meat is then either smoked in a loosely-woven basket suspended over the fire, or boiled.

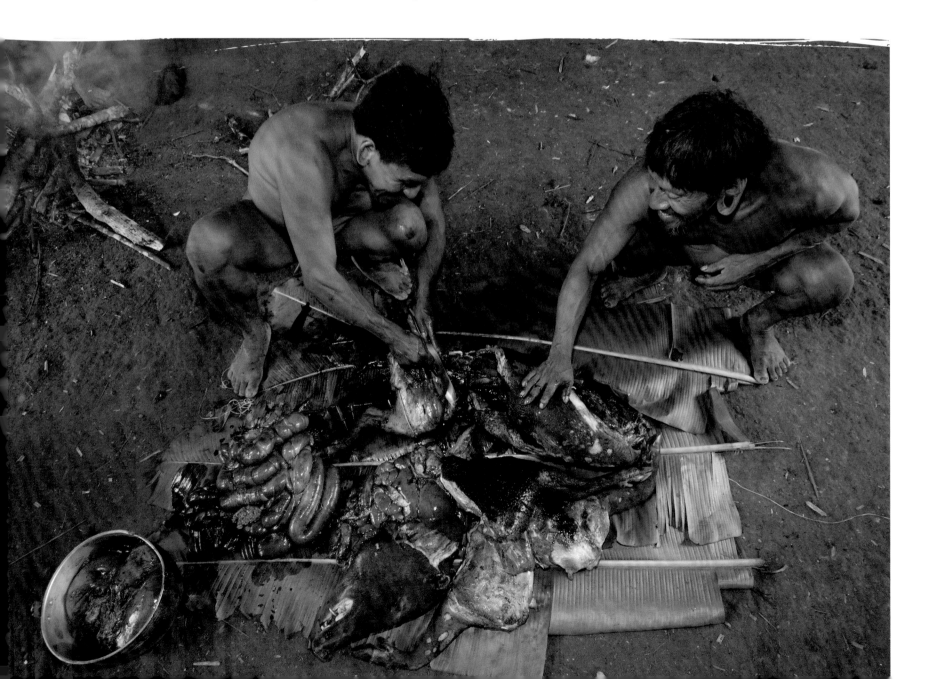

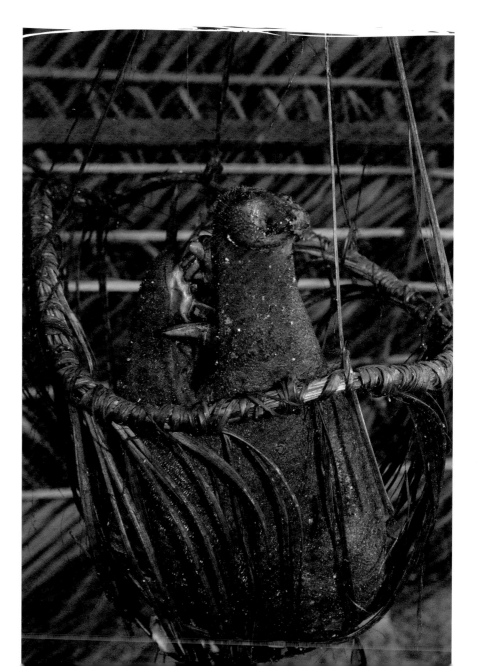

"When the missionaries came to Africa,
they had the Bible and we had the land.
They said 'let us close our eyes and pray.'
When we opened them, we had the Bible,
and they had the land."

Archbishop Desmond Tutu.

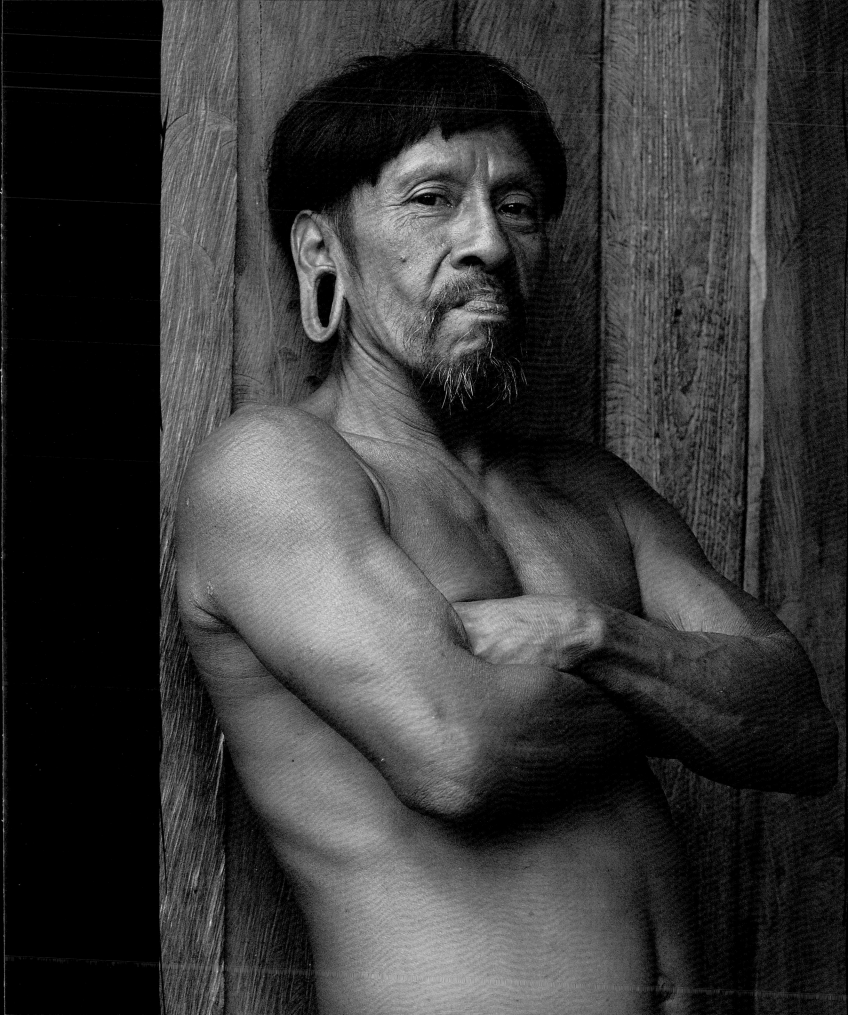

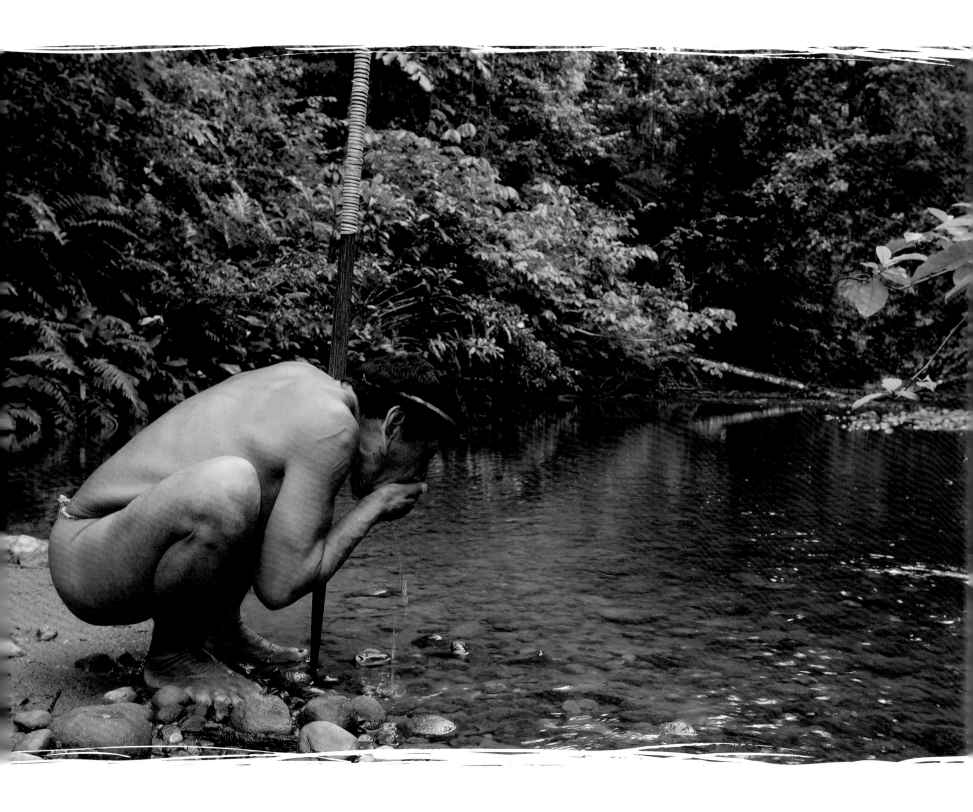

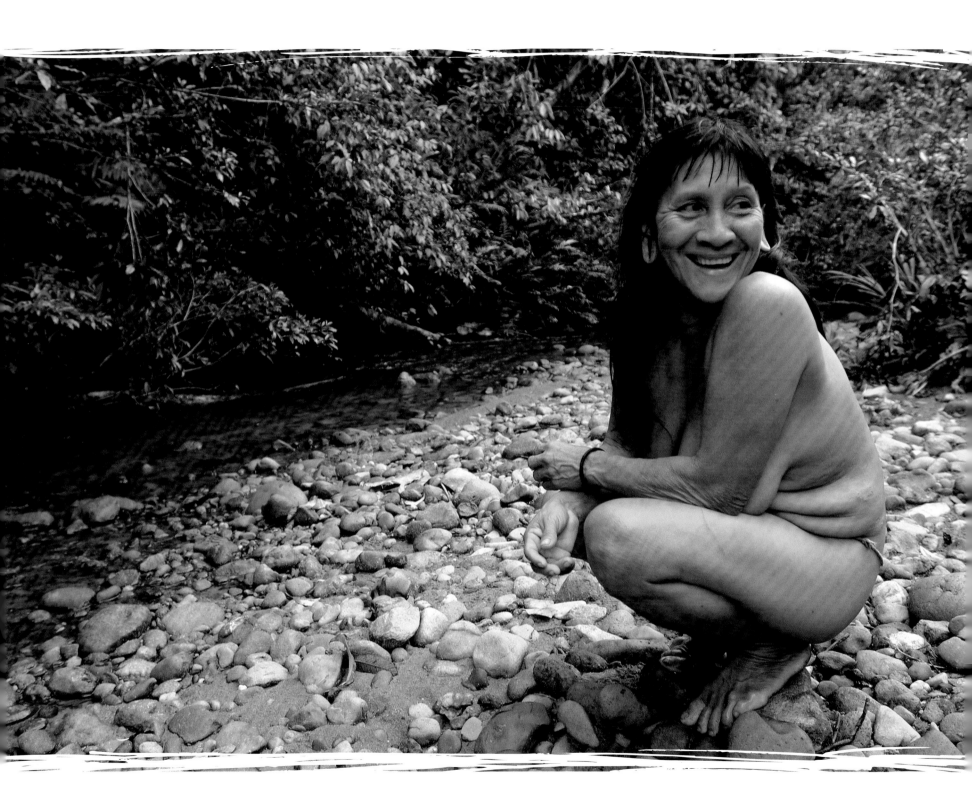

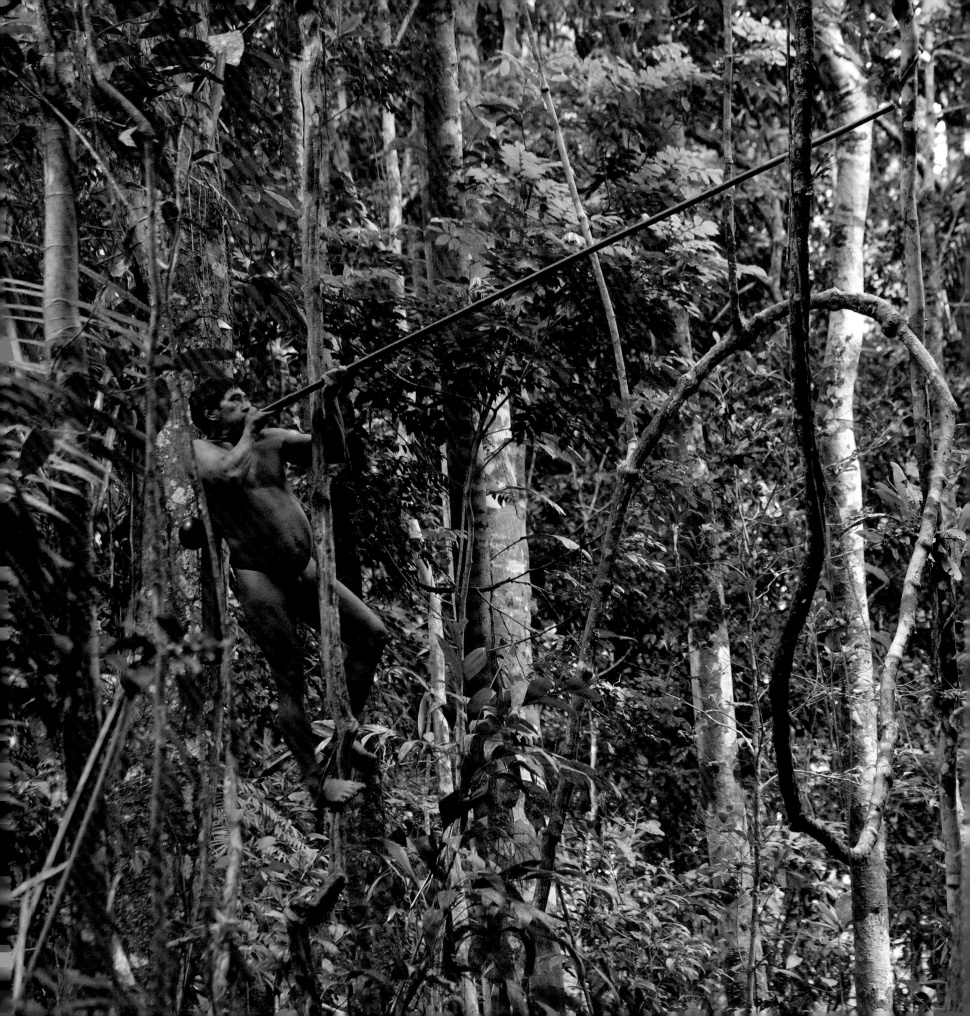

"No man finds it
difficult to return to
nature except the man
who has deserted nature."

*Seneca (4 BC-AD 65), Roman
statesman and philosopher.*

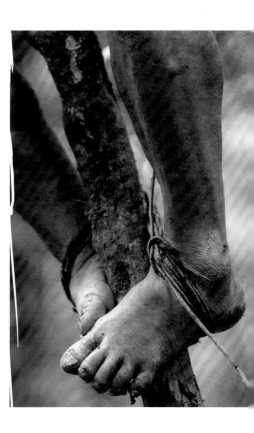

"And forget not that the earth delights to feel your bare feet."

Kahlil Gibran, The Prophet, 1923.

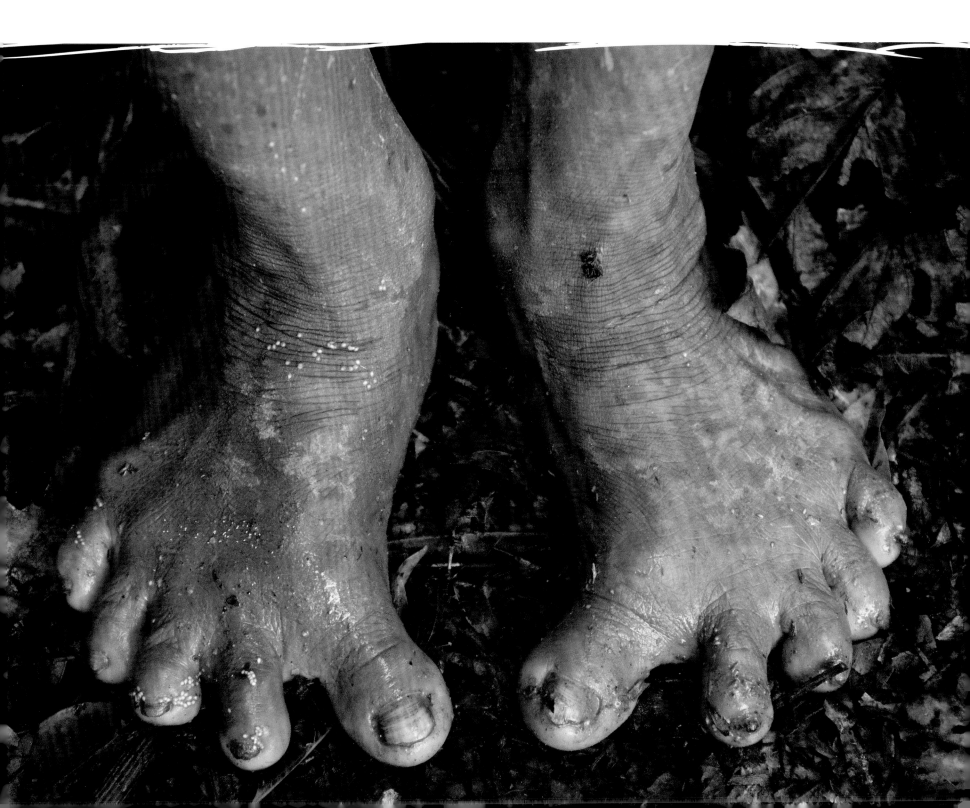

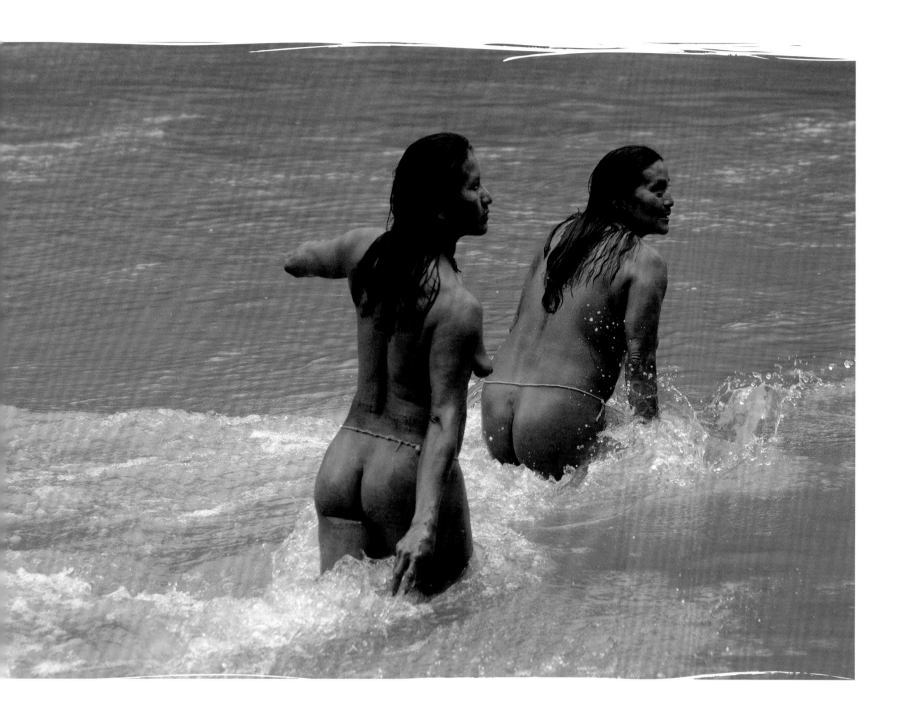

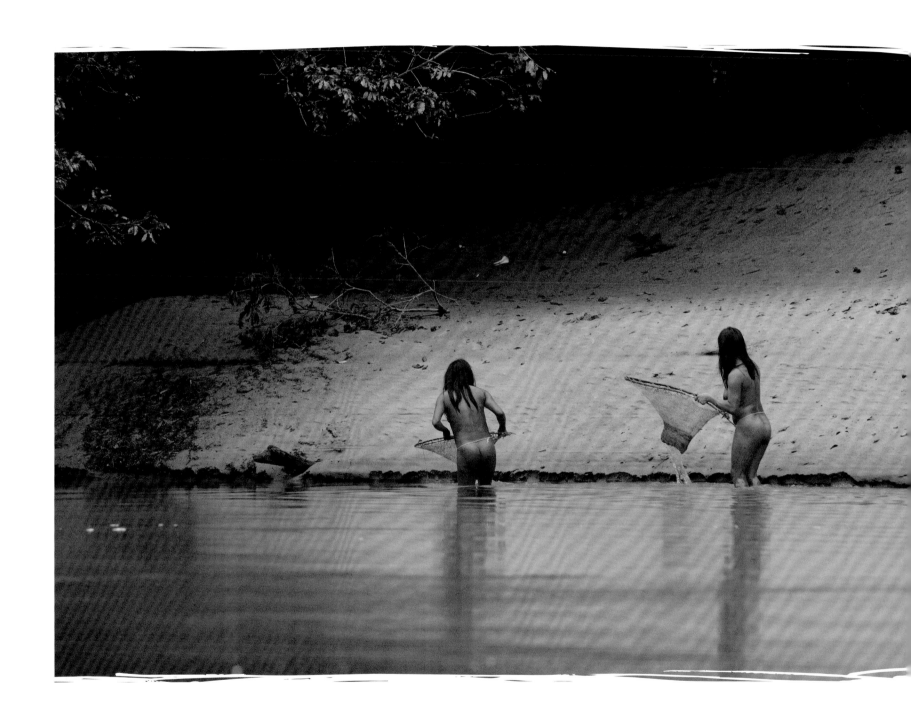

"The goal of life is living in agreement with nature."

Zeno (335-263 BC), Greek Stoic philosopher.

Bameno community members with their recently-issued Ecuadorian ID cards.

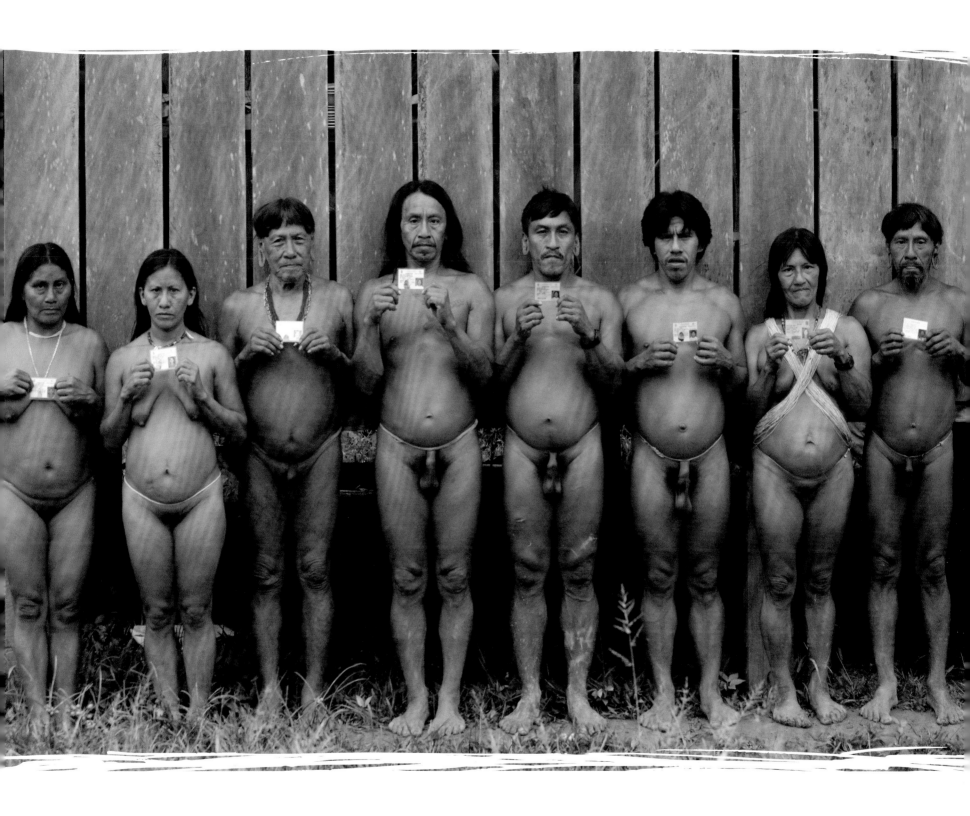

sting Composer, singer, actor, activist – Sting has won universal acclaim in all these roles, and still continues to explore new avenues for his creative talents.

Since forming The Police in 1977, and then pursuing a solo career from 1985, Sting has earned sixteen Grammy Awards, four Brits, a Golden Globe, an Emmy and three Oscar nominations.

In 2006 Sting released the album Songs from the Labyrinth with lutanist Edin Karamazov, featuring the lute music of acclaimed Elizabethan composer John Dowland. Sting has also appeared in more than ten films and in 1989 starred on Broadway in The Threepenny Opera. His autobiography Broken Music was published in 2003 to great critical acclaim. In 2007 he regrouped with fellow members of the Police for a world tour.

In 1989, Sting and Trudie Styler founded the Rainforest Foundation to protect the world's rainforests and their indigenous peoples, and have raised more than $23million for the organization which now works in 18 countries around the globe.

trudie styler Trudie Styler is an actress, film producer, director, organic farmer, environmentalist, human rights activist and Unicef Ambassador.

Trudie's production credits with her company Xingu Films include several acclaimed documentaries for ABC and the BBC and ABC, including the IDA-award winning MOVING THE MOUNTAIN (1994), directed by Michael Apted, and the making of a Disney animated feature THE SWEATBOX, which she co-directed in 2002. Feature film credits include THE GROTESQUE (1996), Guy Ritchie's first two films LOCK, STOCK AND TWO SMOKING BARRELS (1998) and SNATCH (2000) which she executive produced; GREENFINGERS (2001); CHEEKY (2003); ALPHA MALE (2005); and A GUIDE TO RECOGNIZING YOUR SAINTS (2006) which premiered at the Sundance Film Festival, winning both the Directing Award for its writer/director Dito Montiel, and the Special Jury Prize for Outstanding Ensemble Performance. Commissioned by Glamour magazine, Trudie also directed her first short film entitled WAIT in the summer of 2005 in New York.

Trudie's acting credits include a guest appearance in FRIENDS (2001), a major role in the ABC series EMPIRE (2004), and the highly acclaimed BBC series LOVE SOUP (2005). Her most recent film roles include CONFESSIONS OF AN UGLY STEPSISTER (2001); ME WITHOUT YOU (2001); CHEEKY (2003) and ALPHA MALE (2005).

Her work as an environmentalist and human rights activist ranges from organic farming and campaigning for the Soil Association, to battling against the injustices done to the indigenous peoples of Ecuador and Brazil. Trudie's recent work for Unicef has taken her to Sri Lanka, Pakistan and Ecuador, and she has raised nearly £2million for Unicef's Emergency Fund over the last two years.

In 1988 Trudie co-founded The Rainforest Foundation with husband Sting, and since 1993 she has produced benefit concerts at Carnegie Hall, securing the talents and enthusiasm of some of the world's most prestigious artists and raising $23million for the cause.

pete oxford

Naturalist, biologist, photographer, conservationist and writer.

Pete has traveled extensively around the globe in pursuit of his images. Equally passionate about wildlife and indigenous culture he is adamant that the preservation of both is inextricably linked.

He came to live in Ecuador in 1985 and has come to know the region and its people well. His greatest love in this diverse country is the Amazon where he has worked as a professional naturalist guide, co-built an ecotourism lodge and been on the board of directors of another. Pete is internationally recognized as a photographer with ten winning images in the BBC Wildlife Photographer of the Year awards, and many more in other prestigious events. His work has been exhibited in Quito, Ecuador; Perpignon, France; Washington DC, Teluride Mountain Film Festival, Jackson Hole and Boulder, USA.

His numerous articles and images have appeared in *National Geographic, BBC Wildlife, International Wildlife, Nature's Best, GEO, Smithsonian, The Times* and *African Geographic* amongst others. He is a founding fellow of the *International League of Conservation Photographers*.

reneé bish

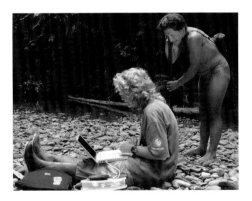

Naturalist, designer, sculptor, nurse and photographic partner.

Together with her husband Pete Oxford, Reneé has traveled around the world, visiting each of the seven continents, every year for eight years. Originally they led wildlife, photographic and indigenous culture expeditions, often to some extremely remote areas. Today they mostly travel alone on photographic quests. They have worked particularly extensively in Botswana, Madagascar, India, Ecuador, Peru, Brazil and Mongolia. Reneé met Pete in the Ecuadorian Amazon in 1992 while she was working as an *haute couture* designer for Bob Mackie on 5th Avenue, New York. Within two months of meeting, Reneé had left New York and found herself resettled in the jungle where she commuted her skills to setting up and running a sewing center for the local Quichua women, a few of whom already possessed a Singer treadle sewing machine as prize possessions in their huts. She later co-built a very successful ecotourism lodge on the Napo River in the Ecuadorian Amazon. Reneé works with Pete as the backbone in their partnership. This is their eighth book.

bibliography

- Aguirre, Milagros. ¡A quién le importan esas vidas! Quito, Ecuador: Cicame, 2007.
- Beyond the Gates of Splendor, A True Story of the Ultimate Sacrifice. 20th Century Fox, 2005. [Documentary].
- Blomberg, Rolf. Los Aucas Desnudos, Una reseña de los indios del Ecuador. Cayambe, Ecuador: Ediciones Abya-Yala, 1996.
- Broennimann, Peter. Auca on the Cononaco. Indians of the Ecuadorian Rain Forest. Boston. Stuttgart: Birkhäuser Publishers, 1981.
- Cabodevilla, Miguel Angel. Los Huaorani en la historia de los pueblos del oriente. Quito, Ecuador: Cicame, 1999.
- Elliot, Elisabeth. The Savage My Kinsman. California USA: Regal Books from Gospel Light, 1961.
- End of the Spear, Dare to Make Contact. 20th Century Fox, 2006. [Feature Film]
- Hitt, Russell T. Jungle Pilot. Grand Rapids, MI, USA: Discovery House Publishers, 1959.
- Kane, Joe. Savages. New York, USA: Vintage Books, 1995.
- Kingsland, Rosemary. A Saint Among Savages. London: Collins, 1980.
- Labaca, Mons. Alejandro. Cronica Huaorani. Quito. Ecuador: FEPP, 1988.
- Oxford, Pete, Reneé Bish. Amazon Images, A Portfolio of Impressions from the Ecuadorian Amazon. Quito, Ecuador: Dinediciones, 1995.
- Patzelt, Erwin. Los Huaorani, Los Últimos Hijos Libres Del Jaguar. Quito, Ecuador: Trama, 2002.
- Paymal, Noemi, Catalina Sosa. Amazon Worlds, Peoples and Cultures of Ecuador's Amazon Region. Quito, Ecuador: Sinchi Sacha Foundation, 1993.
- Rival, Laura. Right to a Way of Life. Resurgence Magazine, Issue 189.
- Rival, Laura. The Growth of Family Trees: Understanding Huaorani Perceptions of the Forest. Man No. 28 (December 1993), 635-652.
- Rival, Laura. Trekking Through History: The Huaorani of Amazonian Ecuador. Columbia University Press, 2002.
- Saint, Steve. End of the Spear. Saltriver, USA: Tyndale House Publishers, Inc., 2005.
- Smith, Randy. Huaorani, Crisis Under The Canopy. Cayambe, Ecuador: Ediciones Abya-Yala, 1993.
- Wallis, Ethel Emily. Aucas Downriver. Dayuma's Story Today. USA: Harper & Row, 1973.
- Wallis, Ethel Emily. Dayuma Life Under Waorani Spears. Seattle, WA, USA: Ywam Publishing, 1996.

index

acknowledgements

Unusually, and for reasons beyond our control, my wife, Reneé, was unable to accompany me on many of my excursions into Huaorani territory, which I hope, explains why the text in this book has become so personal and very much one-sided. Reneé, I thank you for your strength and for being my corner-stone.

Together we would like to thank the Huaorani themselves for allowing me so completely into their world. Ahua Baiwa, Awame Gomoke, Bain Kaiga, Baiwa Miipo, Bebanca Wane, Boya Apika, Capitan, Carmen Kaiga, Dabe Baiwa, Dete Iteka, Ene Kaiga, Epanka Kaiga, Ewa Kemperi, Eweginto Tega, Fidel Kaiga, Gaware Wane, Geme Baiwa, Gewa Kaiga, Kabowe Tega, Kobari Tega, Kano Yeti, Konta Ñamaronke, Kemeya Tobekawa, Kempere Tega, Kope Tega, Megatowe Ontogamo, Meñemo Bopoga, Meñewa Wane, Menga Darita, Mima Ainwa, Minihuá Boya, Mipo Wira, Moi Enomenga, Ñama Wani, Namo Yate, Ñatera Wane, Nemonte Ainwa, Norma Kaiga, Okaginke Apika, Omano Tega, Oña Yate, Ontogamo Kaimo, Otobo, Pirahua, Romelia Andy, Tage Kaiga, Tepa Boya, Teti Tega, Wane Baiwa, Ware Baiwa, Weca, Wenyeya Baiwa, Wira Kaiga, Yero Mantahoe, Yowe Tega.

A very special thank you goes out to Trudie Styler and Sting not only for their unreserved support of our work and this project but also for writing such a poignant foreword. Furthermore a thank you to their team, in particular, Anita Sumner, Helen Fairclough, Kate Henderson, Noel Hart, Theresa Lowrey and Emily Strike.

Samuel Caento Padilla and Jeanne Elliott for being the beginning of it all.

Fabian Ima Nenquimo without whose energy, enthusiasm and unselfishness the project would never have materialized at all.

To Belen Mena for so perfectly enabling me to express my dreams.

At Dinediciones, Fidel Egas, Hernán Altamirano, 'Pájaro' Febres Cordero and Juana Ordoñez.

Paco and Andy Valdivieso of Imprenta Mariscal for their professionalism and support and also their team, particularly Isaac Canales, Enrique Gallardo, Vicente Herrera, Gustavo Moya and Lucy Vargas for their incredibly long hours.

The Vice President of Ecuador, Lenín Moreno, Maria Sol Corral, Esperanza Martinez, Manuel Pallares, Juan Martinez & Catalina Sosa.

Dominic Hamilton, who not only squeezed the English text into shape but has been a great neighbour.

Maricruz González, as always, for her willingness to perfect her already excellent translation into Spanish. Paulina Rodriquez for crossing the "t"s and dotting the "i"s.

Clarice Strang for being so 'earthy', jumping straight in and always so willing to help.

Other friends who in one way or another deserve a special mention are:

Dorothy Albright, Ramiro Almeida, María Cecilia Alzamora, Beny Ammeter, Margara Anhalzer, Erika Arellano, Juan Lorenzo Barragán, María Elena Barragán, Ximena Benavides, Peter Bennett, Karin Behnert, Daniel Blanco, Jean Brown, Andrés & Andrea Bustamante, Felipe Campos, Alfredo Carrasco, Jascivan Carvalho, Roberto Corradini, Guillermo Corral, Georgina Cruz, Sebastian Cruz, Judith Denkinger, Ben Dod, Andy Drumm, Lucy Durán, Luis Fernando Escobar, Captain Fernando Espinosa, Patty Fiallos, Matt Finer, Felipe Fried, Marcela García, Belen Garrido, Diego Guarderas, Caroline Hamilton, Sylvia Harcourt, Hugo Jara, Patricio & Ivette Jiménez, Rosamund Kidman Cox, Cecilia Losada, Álvaro Mantilla, Cristina Mittermeier, Margarita Mora, Ponto Moreno, Charlie Munn, Alexis Naranjo, Lisanne Newport, Jan Niedrau, Gary Parkin, Danilo Pasternak, Diana Pazmiño, Fiona Perez, Tom Quesenberry, John Rosenberg, Miguel Samañego, Mike Sauer, Ana Lucía Sosa, Mariela Tenorio, Mariana Valqui, Roeland Van Lede, Sally Vergette, Gerardo Villacreces, Andy Watkins, Graham Watkins, Sophia Watkins, Guillermo & Roxana Zaldumbide.

To our main photographic agents: Helen Gilks and her staff at Nature Picture Library (www.naturepl.com) as well as to Larry Minden and his staff at Minden Pictures (www.mindenpictures.com)

Lastly, to our parents whom we would love to get to see more often, Roy and Very Wood and Meg Oxford.

FRIENDS OF THE HUAORANI AND YASUNÍ

The Rainforest Foundation: www.rainforestfoundationuk.org
Rainforest Foundation US: www.rainforestfoundation.org
Save Americas Forests: www.saveamericasforests.org
Rainforest Concern: www.rainforestconcern.org
Yasuni depends on you: www.sosyasuni.org
Acción Ecológica: www.accionecologica.org

Spirit of the Huaorani: Lost Tribes of the Yasuní

2nd edition 2009

Photo of Trudie Styler: Patrick Demarchelier
Photo of Sting: Kevin Mazur

Editor: Dominic Hamilton

Design: belénmena . www.belenmena.com
Cover design: Pete Oxford and Reneé Bish
Map illustration: Bladimir Trejo - Sesos CV

Printed in China
All rights reserved

Note: Nothing was digitally added or removed from these images with the exception of page 1 where some extraneous matter around the huts was removed.

Contact: pete@peteoxford.com
 www.peteoxford.com

Published by Imagine Publishing, Inc.
25 Whitman Road, Morganville, NJ 07751

Text and Photography © 2009 by Pete Oxford and Reneé Bish

Distributed in the United States by:
BookMasters Distribution Services, Inc.,
30 Amberwood Parkway
Ashland, OH 44805

Distributed in Canada by:
BookMasters Distribution Services, Inc.
c/o Jacqueline Gross Associates
165 Dufferin Street
Toronto, Ontario, Canada M6K 3H6

Distributed in the United Kingdom by:
Publishers Group U.K., 8 The Arena, Mollison Avenue,
Enfield, EN3 7NL, U.K.

ISBN 13: 978-0-9822939-1-1
ISBN 10: 0-9822939-1-7
Library of Congress Control Number: 2009922010

Putting names to the faces

Page 7, Kobe Tega, Bameno.
Page 14, Baiwa Miipo, Bameno
Page 15, Boya Apika, Bameno.
Page 16, Ahua Baiwa, Bameno.
Page 17, Meñewa Wane, Bameno.
Page 26, Dabe Baiwa, Gabaro.
Page 27, Meñemo Bopoga, Awame Gomoke,
 Ewa Kemperi, Bameno.
Page 28, Ontogamo Kaimo, Gabaro.
Page 29, Geme Baiwa, Gabaro.
Page 30, Konta Ñamaronke, Gabaro; Ewa Kemperi, Bameno.
Page 31, Wene, Bameno, unrecorded.
Page 32, Ontogamo Kaimo, Gabaro.
Page 33, Dete Iteka, Bameno.
Page 34, Tage and Norma Kaiga, Gabaro.
Page 35, Unrecorded.
Page 36, Kabowe Tega, Coca.
Page 37, Kempere Tega, Bameno.
Page 39, Weca, Gareno.
Page 40, Minihuá Boya, Gareno.
Page 41, Weca, Gareno.
Page 42, Mima, Bameno.
Page 44, Ñama Wani, Bameno.
Page 46, Kempere Tega, Bameno.
Page 47, Wenyeya Baiwa, Gabaro.

Page 48, Tage Kaiga, (top), Carmen Kaiga, Gabaro.
Page 49, Dete Iteka and child, Bameno.
Page 52, Bebanka Wane, Bameno.
Page 53, Awame Gomoke, Bameno.
Page 54, Yero Mantahoe, Quito.
Page 56, Oña Yate, Coca.
Page 58, Boya Apika, Bameno.
Page 59, Dete Iteka, Bameno.
Page 60, Tage Kaiga, Gabaro.
Page 62, Tage Kaiga, Gabaro.
Page 63, Megatowe Baiwa, Gabaro.
Page 67, Gewa Kaiga, Gabaro.
Page 70-71, Children from the Gabaro community.
Page 74, Kempere Tega, Bameno.
Page 76, Carmen Kaiga, Gabaro.
Page 77, Norma Kaiga and Romelia Andy, Gabaro.
Page 78, Romelia Andy, Gabaro.
Page 81, Yadira Baiwa, (left), Omamo Tega, Gabaro.
Page 82, Menga Darita, Gabaro.
Page 83, Mipo Wira, Gabaro.
Page 86-87, Ewa Kemperi, Awame Gomoke, Bameno.
Page 88, Awame Gomoke, Dete Iteka, Bameno.
Page 89, Meñemo Bopoga, Bebanca Wane, Bameno.
Page 90, Carmen Kaiga, Gabaro.
Page 91, Kano Yeti, Gabaro.

Page 93, Ewa Kemperi, Bameno.
Page 94, Dabe Baiwa, Gabaro, Meñemo Bopoga, Bameno.
Page 97, "Capitán", Quito.
Page 100, Moi Enomenga, Quito.
Page 101, Unrecorded.
Page 102, Wenyeya Baiwa, Gabaro.
Page 103, Tage Kaiga, Gabaro.
Page 104, Kope Tega, Bameno.
Page 106, Ware Baiwa, Gabaro.
Page 112, Pirahua, Gareno.
Page 114, Konta Ñamaronke, Gabaro.
Page 120, Ahua Baiwa, Bameno.
Page 121, Meñemo Bopoga, Bameno.
Page 122, Unrecorded.
Page 124, Dabe Baiwa, Gabaro.
Page 125, Bebanca Wane, Bameno.
Page 128, Ontogamo Kaimo, Gabaro.
Page 129, Romelia Andy, Gabaro.
Page 130, Baiwa Miipo, Meñewa Wane, Bameno.
Page 133, Meñewa Wane, Bameno.
Page 134, Minihuá Boya, Gareno.
Page 135, Tepa Boya, Gareno.
Page 136, Ontogamo Kaimo, Gabaro.
Page 140, Ewa Kemperi and Dete Iteka, Bameno.